W9-BWF-911

CONTENTS

LAURA MORELLI'S AUTHENTIC ARTS

VENICE

A Travel Guide To Murano Glass,
Carnival Masks, Gondolas,
Lace, Paper, & More

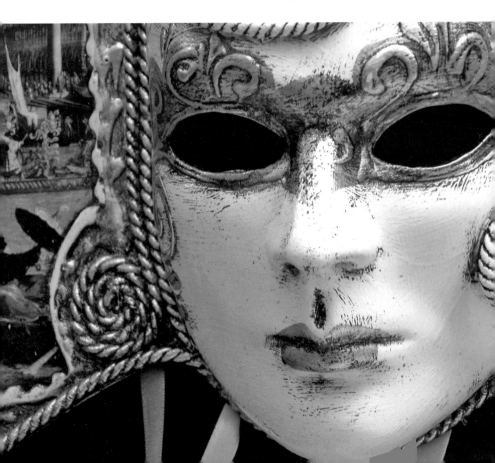

Published in the United States of America.

LAURA MORELLI'S 🅰 AUTHENTIC ARTS

Library of Congress Control Number 2014909164

Paperback ISBN: 978-0-9893671-3-4

eBook ISBNs: 978-0-9893671-5-8 (ePUB), 978-0-9893671-4-1 (mobi)

Laura Morelli's Authentic Arts: Venice / The Scriptorium. —1st ed.

Image Credits:

EPIGRAPH: © Shutterstock / Katoosha. **INTRODUCTION:** © Depositphotos.com / mikdam. **CHAPTER 1:** p. 2 © iStock.com / AnetteAndersen; p. 5 © Depositphotos.com / Captblack76; p. 10 © Depositphotos.com / lachris77; p. 12 Creative Commons courtesy of Nick Thompson / Flickr; p. 13 © iStock.com / achiartistul. **CHAPTER 2:** p. 16 © inavanhateren / 123RF; p. 20 © Shutterstock / jurra8; p. 22 © Eric Le Fichoux / Fotolia; p. 24 © Depositphotos.com / sedmak; p. 26 Creative Commons courtesy of John Hann / Flickr. **CHAPTER 3:** p. 32 © iStock.com / vesilvio; p. 35 © doroth / Fotolia; p. 39 © Depositphotos.com / stefanocapra; p. 40 © iStock.com / rubiophoto. **CHAPTER 4:** p. 42 Giovanni Antonio Fasolo, *Portrait of a Venetian Noblewoman of the Age of 18*, oil on canvas, Courtesy of the Gösta Serlachius Fine Arts Foundation, Mänttä, Finland; p. 47 © age fotostock; p. 48 © iStock.com / achiartistul; p. 50 © Depositphotos.com / ABCDK. **CHAPTER 5:** p. 54 © Gloria Guglielmo / Fotolia; p. 58 © iStock.com / sergeyskleznev; p. 59 © Folco Banfi / Dreamstime.com; p. 60 Pietro Longhi, *The Rhinoceros in Venice* (detail), 1751, Creative Commons courtesy of The National Gallery, London; p. 61 © Depositphotos.com / masterlu; p. 62 © iStock.com / kvkirillov; p. 64 © Shutterstock / Grigory Iofin; p. 65 Jan Grevenbroeck the Younger, masked doctor during the plague in Venice, from the Grevenbroeck manuscript, 17th century, Museo Correr, Venice, Erich Lessing / Art Resource, NY; p. 66 © Nordic Photos. **CHAPTER 6:** p. 68 © iStock. com / grandaded; p. 73 © Shutterstock / Josef Zima; p. 75 © Depositphotos.com / thepoeticimage, © iStock.com / grandaded, © iStock.com / AndyMagee; p. 76 © iStock.com / aeduard; p. 77 Creative Commons courtesy of Alessandra Elle. **RESOURCES:** p. 78 © Depositphotos.com / alexvav3; p. 84 © Depositphotos.com / freeteo; p. 87 © Laura Morelli; p. 89 © iStock.com / Tashka. **AUTHOR PHOTO:** Sarah DeShaw.

I had had my dreams of Venice.
But nothing that I had dreamed was
as impossible as what I found.

—ARTHUR SYMONS, *CITIES*, 1903

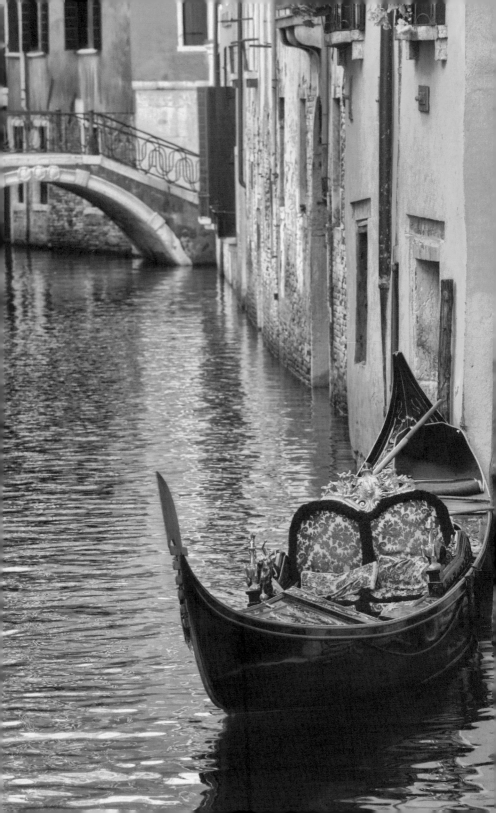

Venice rises from a marshy Adriatic lagoon like a surreal vision: a complicated jumble of meandering canals, mosaic-encrusted churches, gothic palace façades, and candy-striped gondola moorings. If you had no prior knowledge of Venice and heard someone describe it, you might find it hard to believe they were telling the truth.

This "impossible" city is not a land mass at all, but rather a cluster of some one hundred shifting islands linked by more than four hundred bridges and canals. The entire built environment of Venice—from the humblest coffee shop to the Basilica of San Marco—stands on a foundation of wooden pilings driven one after another, side by side, vertically down into the water, into the mud. This unlikely way of constructing a city began during the perilous years of the early Middle Ages, when people sought protection among the lagoon islands from potential attackers. As the centuries passed and the population grew, the locals continued to drive pilings into the marshes to build their city. The wood did not rot because it was not exposed to oxygen; instead, it petrified into a hardened, stone-like foundation upon which sat even the most extravagant buildings constructed during the heyday of the Venetian Republic, between the fourteenth and seventeenth centuries.

Out of this fantastic, waterlogged cityscape, extraordinary artistic traditions have emerged: deeply hued glass, web-like lace, hundreds of different types of boats suited to the lagoon, carnival masks, leather-bound books, and colorful paper. These artistic traditions first lured me to Venice, and they have kept me coming back for nearly four decades. It's impossible not to want to take a little piece of Venice home in your suitcase. In our world of megastores, corporate chains, and mass production, many of us are hungry for unique, culturally authentic and immersive experiences. I can think of no better way to appreciate Venetian culture than by experiencing the stories, the people, and the objects behind the artisanal traditions of this impossible city.

How to Shop in Venice

Let's get one thing out of the way up front: shopping in Venice can be intimidating. All of us want to come home from La Serenissima with a special souvenir, but selecting which carnival mask or which piece of Murano glass to buy can be an overwhelming experience. How do you know if you're buying something authentic, something made in Venice, something made in a traditional way? How do you gauge how much you should pay, and how do you know if you're being ripped off? How do you determine if you have fallen prey to one of the city's many tourist traps?

When I was a teenager, I had the fortune to visit Venice for the first time. I had a preconceived notion that I was supposed to go home with Murano glass, but honestly, I had no idea why. I was lured to the famous "glass island" of Murano by a fast-talking hawker in the Piazza San Marco and whisked onto an overcrowded, stinky boat. After a whirlwind factory tour, I waited in line behind several dozen American and Japanese tourists to pay an exorbitant price for a little green glass fish. Today the fish sits on the windowsill of my study as a testament to this bewildering experience.

Even after my Murano glass-buying debacle, the artistic traditions of the world still lured me to travel and inspired me

to pursue advanced studies in art history. Eventually it became my mission to lead travelers beyond the tourist traps to discover authentic, local, handmade traditions. My focus is on cultural immersion through a greater appreciation of authentic arts and the people who make them.

In the following sections, you will find specific guidance on how to recognize quality and value in the most traditional Venetian arts. If you follow these guidelines, when you do find a treasure, you will know it beyond a doubt, and the touristy kitsch lining the streets will fade into the background. The richness and tradition of Venetian authentic arts make sorting through the tourist traps to discover a treasure not only worth the effort, but especially rewarding.

Although some Venetian shops break the tradition of closing at lunch in order to accommodate tourist traffic, most stores and businesses in Venice follow the Italian tradition of opening around 9:00 or 10:00am, then closing around noon or 12:30pm for the midday meal. A two- or three-hour siesta can be frustrating for some international travelers who are unaccustomed to the midday hiatus and are trying to pack as much as possible into the day. There is not much to do about it other than sitting at a table and ordering a glass of Prosecco and a plate of risotto, so enjoy! Most shops reopen around 3:30pm, and remain open until around 7:30 or 8:00pm.

Keep in mind that many of the individual workshops you will want to visit and buy from may not adhere to this schedule at all. It is common to find an artisan studio inexplicably closed. Sometimes you will find a note on the door indicating what time they expect to return; other times you may find the shop battened down during regular business hours with no indication of their plans to reopen. It's all part of the serendipity of exploring Venice, so keep an open mind.

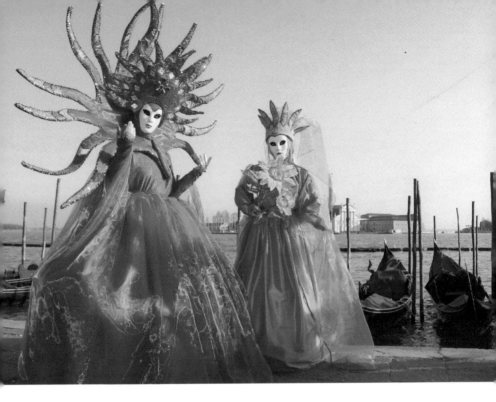

Why does everything look so... Venetian?

As you wander the streets of Venice, you will quickly absorb the city's visual style—opulent, vibrant, and dominated by a rich palette of crimson, sapphire blue, and gold. Venetian wares are fancy: handmade wooden furniture with curvilinear forms and gilded scrolls; blown glass with delicate swirls and rich, saturated color; lace collars with intertwined vegetal motifs; mosaic work on vases, lamps, buildings, and many other surfaces; whimsical masks and elaborate costumes. Perhaps in no other city in the world are its foremost artistic traditions—gondolas, Murano glass, and carnival masks—virtually synonymous with the city itself.

The opulence of Venetian style is deeply rooted in time. In the history of art, Venice plays a unique and important role. In addition to its novel political organization—hailed as a model of government during the Middle Ages and the Renaissance—the Venetian Republic's influence stretched far beyond the waterlogged city. Its

FINDING YOUR WAY

Venice boasts one of the most confusing address systems in all of Italy, and that's saying a lot in a country where each city has its own unique way of denoting addresses. Venice is divided into several districts or *sestieri*: Cannaregio, Castello, Dorsoduro, San Marco, San Polo, and Santa Croce. Within each district addresses are numbered consecutively, so a typical address might read "Dorsoduro 3652," meaning that it is building number 3652 in the district of Dorsoduro. Sometimes streets have a name, and sometimes they don't. Sometimes they have more than one. Sometimes they are written in Venetian dialect, sometimes in Italian. Sometimes even and odd numbers are located on the same side of the street, and sometimes they are on opposite sides. By all means buy a map, but prepare to get lost anyway, and enjoy!

geographical location, poised on the edge of the Eastern world, made it an important point of departure for western pilgrims and crusaders. In the Middle Ages the powerful Republic of Venice colonized the eastern Mediterranean. Venetian merchants and mercenaries alternately pummeled and traded with some of the most illustrious cities of the East, especially Constantinople. This strategic location also made Venice a point of entry for luxury goods and plundered wares from the Byzantine and Arab worlds. As Venetian Crusaders looted Eastern cities and brought home their booty, local artists were influenced by the modes of the Byzantine and Islamic worlds. The city's artistic traditions and forms bear witness to this historical position as a crossroads of East and West. In turn, many of the goods produced in the Venetian Republic were exported or copied elsewhere in Europe.

In addition to this nod toward Eastern modes, Venetian art is also renowned for its luminous colors and shimmering surfaces. Surrounded by the sparkling, reflective waters of the Venetian lagoon, it is only natural that artists would feel inspired to replicate these effects. Artists sought to achieve the most vibrant colors: the rich ruby, sapphire, green and amber used in painting, mosaic, glass, marble, and other materials. Venetian artists used a variety of techniques to impart this lucidity and richness to their materials. Medieval Venetian mosaicists, for example, experimented with applying colored oxides over silver or translucent glass so that light would be reflected back from the *tesserae*, or pieces, they assembled to create mosaics. Venetian painters of the 1500s experimented with grinding shards of Murano glass into their paint pigments to impart a rich translucency and shimmering quality to their oil paintings, a particular Venetian practice whose results brought these painters fame across Europe.

Even after the decline of the Venetian Republic, the distinctive Venetian spirit continued to pervade the city's artistic traditions. Today in Venice, many of the trades of the past are still *living traditions*. The medieval guilds may be long gone, but their arts, their techniques, and their soul still thrive in Venice. The skills, the forms, the knowledge, and more importantly, the spirit of the past, is kept alive in the hands of a small number of individuals who take pride in their city's unique visual essence.

What to Ask Before You Buy

In Venice, it's not easy to tell the treasure from the trash. This is true now more than ever before, as increasing numbers of carnival masks, glass, and other souvenirs flood into Venice, imported from overseas and passed off as authentic. Recently art organizations have worked to develop trademarks and new alliances to help protect their artistic heritage and to guard against fakes and cheap knockoffs. Legal regulations have also tightened. However,

there is no substitute for a knowledgeable buyer. If you know what you are buying, you can put your money where it counts: back into the pockets of Venetian makers and not into those of importers looking to make a quick profit without any connection to Venice at all.

Over years of searching for individuals following authentic, centuries-old artistic traditions, I have developed five questions to help guide you through the minefield of shopping in an unfamiliar environment. If you can come up with a good answer to each of the following questions before you purchase your Venetian souvenir, chances are you will have picked a winner.

1. Is it traditional and locally made?

Before you travel to Venice, read up on its handcrafted traditions. If you're reading this book then you're already well on your way! What sparks your interest? Carnival masks? Glass? Have you considered handmade paper? Go online or to the library and read up before you go. Even a cursory education will help you avoid impulsive and reckless purchases that you may regret later.

As soon as you arrive in Venice, start with the museums that display collections of authentic traditions such as Burano lace, Murano glass, and other handcrafted works with a long history. I am not suggesting that you should go home with a museum-quality work or an antique. The point of starting with the museums is to train your eye. After spending a short time in the local museums, you will begin to absorb the colors, patterns, styles, and forms that are traditionally Venetian. Most of all, you'll be better equipped to spot high-quality, traditionally made wares when you begin to hunt for a souvenir. You can find a list of great museum collections of Venetian arts in the Resources section at the back of this book.

MADE IN... WHERE?

In recent years, knockoffs of traditional Venetian arts have flooded into the city from outside of Italy. This unfortunate trend has made it increasingly difficult for the casual traveler to avoid the pitfalls of shopping in a heavily touristed city, and of course it has also taken profits away from legitimate traditional Venetian artists. Make the extra effort to buy directly from the maker.

In Venice, stick to Venetian-made objects. In other words, it's not a good idea to buy Italian goods made elsewhere, like Florentine leather handbags or Roman marble, because those items are neither traditional nor locally made. They may or may not have been made in Italy, and, purchased out of context you will never know.

There are two good reasons for buying Venetian works in Venice. The first is that you are more likely to get greater value by buying from the source. The second—even more valuable in my opinion—is that you are more likely to make a connection with the person who made it, and that will become part of an immersive travel experience that you will carry with you forever.

2. Who made it?

Buy directly from the maker whenever possible. It's your best guarantee that you will go home with a high-quality, handmade item at the best possible price. The added bonus of getting to know the maker of a carnival mask, for example—and perhaps even watch it being made—is invaluable.

Where can you find these makers? In Venice, it's easier than you may think to find them if you know where to look. Throughout this book, you will find recommendations for specific neighborhoods and streets where you will find working artists clustered together—glassmakers on Murano, lacemakers on Burano, and paper-makers clustered in San Polo, for example. Once you decide what you want to buy, refer to the following chapters and the Resources section at the back of the book for specific recommendations.

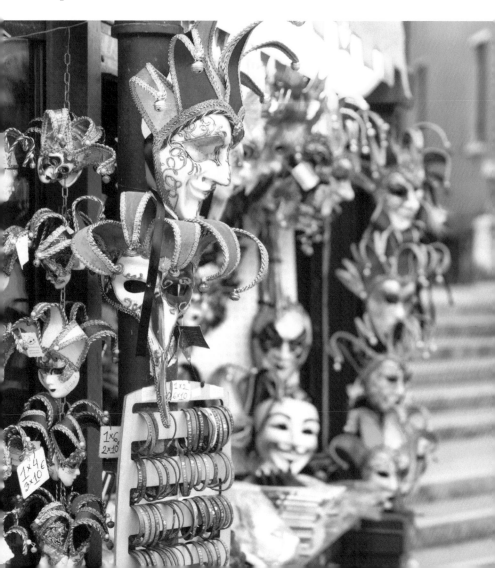

3. Who is selling it?

It's always best to buy a souvenir directly from its maker, but if for some reason that is not possible or practical, here are a few other options. One choice is to buy at one of the annual events and festivals that take place in the city. Check the Resources section for specific events where you may gain access to artists who may not maintain a studio open to the public but meet buyers face to face at these events instead. Another option is to buy from one of the city's museum stores. Museums typically maintain a high quality standard when it comes to items sold in their shops, with a focus on local tradition. However, these options rank far behind the opportunity to observe and interact with local artists. Venice is a year-round extravaganza of richness and culture. Why not avail yourself of the opportunity?

Now, where should you *not* buy? As a general rule, avoid the tourist-oriented retailers that lie along major pedestrian thoroughfares of the city, especially the Rialto Bridge and the main alleys snaking away from the Piazza San Marco, as well as those that lie on the main streets linking San Marco and Rialto. Avoid buying from street stalls or trinket shops surrounding the major sites of the city that draw tourists: the Basilica of San Marco, the Accademia, the Guggenheim, the train station, and similarly crowded venues. In these areas you are nearly guaranteed to overpay for a lower-quality item that may or may not have been made in Venice.

When it comes to buying direct, get as specific as possible! In other words, don't buy Murano glass in the Piazza San Marco. You've already come this far; jump on a boat and head to the famous glass island to see how it's made and meet some glassmakers face to face.

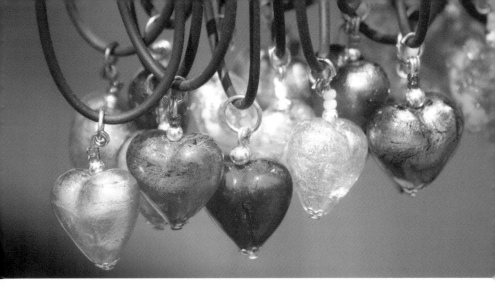

4. How much should I pay?

How much to pay depends on many individual factors. An authentic Venetian gondola may set you back tens of thousands of Euros, but few of us are likely to bring home one of those. After gondolas, Murano glass tends to command the highest prices of all the Venetian traditions, especially those pieces signed by famous designers. Handmade Venetian lace can also be pricey because of the staggering number of hours that must go into crafting each little piece. Some of the greatest values can be found in the category of handmade carnival masks, paper, and bookbinding. The following chapters outline specific guidelines that will help guide what you should look for and how much you should expect to pay.

When buying handmade, traditional wares, price and quality do not always correlate. In other words, a high price does not necessarily mean high quality, and a low price does not necessarily mean that the item is less valuable. Value depends on what you buy and from whom, and this is especially true in a tourist-filled city like Venice. The high-traffic tourist streets command high prices for everything, no matter what the quality. Pay attention to your surroundings; if most of the shops on the street cater to

international tourists, your risk of overpaying for a lower-quality item is high. Instead, head to the quieter, less frequented artisan quarters of town like Dorsoduro and San Polo, known for their authentic makers but not for major tourist attractions.

Remember: a truly authentic souvenir does not have to be expensive, but it may end up being the most *valuable* thing you bring home from your trip to Venice.

5. How will I get it home?

This question is important to ask before separating yourself from your money. There are two aspects of transporting your souvenir that you need to consider.

The first thing to decide is whether you will carry the item with you or ship it home. More portable souvenirs like a piece of jewelry or a set of handmade stationery are ideal for placing

in your suitcase or wearing on the plane. You may be tempted to transport fragile items like glass in your carryon luggage, but remember that if something breaks, you will not have much recourse to replace it once you've boarded the plane.

Bulky or fragile items, or souvenirs such as knives that will not pass airport security, may be shipped. I do not recommend using the Italian (or any country's) postal system, for the simple reason that—even if you've insured it—you will not be able to walk down to the post office and file a claim if your package never arrives. Stick with one of the major international carriers such as FedEx or UPS so that you may insure and track your package. Check your carrier's web site ahead of time to get an idea of shipping rates and times. Some merchants, especially on Murano, are set up to take care of shipping for you. Some even have special packing materials and containers that are ideally suited to protect fragile items. Just ask! Don't forget to exchange email addresses with the merchant and don't leave the shop without your tracking number.

AM I BEING SCAMMED?

Venice is arguably the most touristy place on earth, and naturally it has its share of scams, mostly in the form of overpriced Venetian-looking souvenirs that were made elsewhere. If you want to make absolutely certain to avoid being scammed, before you buy, ask yourself: Is the item traditional of Venice? Do you know who made it? Did you buy it directly from the person who made it? If you answered yes to these three questions, then chances are you do not need to worry about becoming the victim of a scam, and you can rest assured that you're likely paying a fair price for the item by Venetian economic standards.

The second thing to consider is clearing Customs when you arrive home. The Customs Services of most countries post specific regulations on their web sites to guide you through importing goods purchased overseas. Most Americans who travel abroad are familiar with the U.S. restrictions on certain food items like fresh cheeses, wine, and chocolate, but did you know that there are additional regulations related to art objects and items that might be considered "cultural artifacts"? It's a good idea to check your country's Customs web site for a list of items that may be restricted or tariffed before you make a purchase in Venice or anywhere else overseas.

Ready to Buy?

When you are finally prepared to hand over your cash or credit card, go through this checklist:

- ✓ Is the item traditionally Venetian and made locally?
- ✓ Do I know who made it?
- ✓ Am I buying directly from the maker or from a reputable source?
- ✓ Am I getting good value for my purchase (not only in monetary terms but also in terms of an immersive travel experience)?
- ✓ Is the item portable, or worth so much that I am willing to incur the cost and risk of shipping it home?

If you can answer "yes" to these five questions, then you probably picked an authentic Venetian souvenir you will treasure for a lifetime.

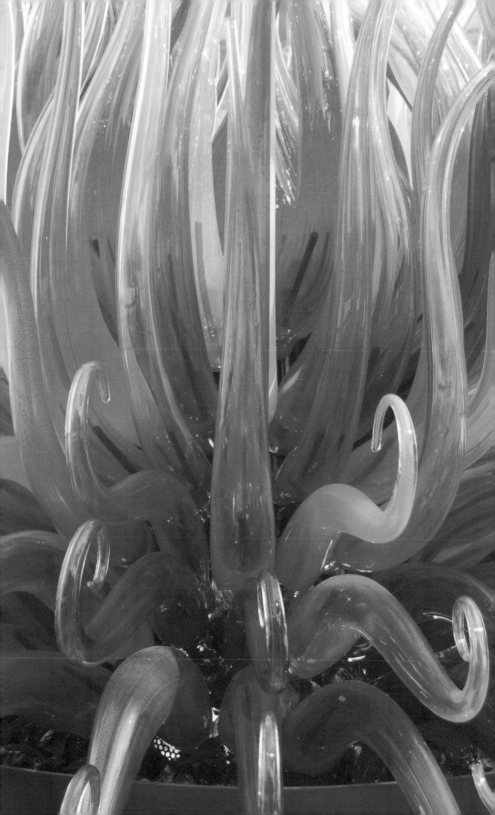

2

Murano Glass

The cluster of islands known as Murano emerges from the Venetian lagoon, a vast expanse of water whose surface reflects every shift in light. Since the thirteenth century, glassmakers have observed these shimmering waters outside their workshops, a vision reflected in the art that has made Murano, and its glass masters, world-famous.

Glass vessels dating from the Roman era have been excavated across the Veneto. Some of these glass works incorporate classic techniques, such as *murrina* that we now associate with Murano glass, and they look remarkably consistent with glass produced in Venice even today. *Fioleri* (glass-, or more specifically, bottle-makers) are noted in Venetian documents as far back as the tenth century, and their name gives an idea of the utilitarian nature of the wares they probably produced at that time: tableware, window glass, and other household items. During the Middle Ages the art of glassmaking must have also been closely linked with mosaic, which was widely used across the city. Venetian mosaicists regularly used glass *tesserae*, or pieces, in creating the mosaics that decorated the floors, walls, and vaults of many of the city's churches. By the 1220s, glassmakers were organized into guilds operating under a strict set of statutes that governed not

only their working conditions but also many other aspects of the glassmakers' lives.

Glassblowers came to be located on Murano for two reasons. The first was to minimize fire risk in Venice. The great number of glass-firing ovens—which regularly reached some 1500 degrees Celsius—produced beautiful glass objects but also initiated fires in the city. The fire hazard must have become onerous because by the 1270s, city officials had begun to transfer glass workshops from the center of Venice to Murano, a process completed by 1291. The second reason to relocate glassmakers to Murano was probably political. Trade secrets of Murano glassmaking were already being leaked across Europe during the Middle Ages, and sequestering glassmakers on Murano allowed the Republic to control glass production and exportation, ensuring that these secrets remained in Venice. Glassmakers faced steep fines or even imprisonment if they traveled outside the Republic, though interestingly, glassmakers from Dalmatia, Bohemia, and elsewhere were occasionally authorized to work on Murano. Until the sixteenth century, Murano glassmakers held a monopoly on European glassmaking, and their stunning creations brought them renown across the world.

We know something about early Venetian glassmaking techniques thanks to a work called *L'Arte Vetraria* ("glass art"), written by Antonio Neri in 1612. Neri's work outlines the most valued types of Murano glass at that time, noting that it was the delicacy, lightness, and translucency of Murano glass that brought it fame.

Although the majority of Venetian glassmakers named in historical documents were men, some female glassmakers' names appeared as early as the 1500s, especially in connection with beadmaking, whose practitioners formed their own separate guild. Many thousands of these beads made their way to Africa and North America, where they were used as currency and as embellishment for clothing well into the modern era. Even today

early Venetian "trade beads" can be found on objects as disparate as a Native American purse or an African headdress.

The glassmaking trade faced hardships toward the end of the 1600s, when economic difficulties and plague outbreaks hit Venice particularly hard. Murano glassworkers also lost their monopoly on the exportation of certain types of glass and mirrors to the French royal manufactures, and other European glass-making centers rose to prominence. The Venetian guilds were officially dismantled in the first few years of the 1800s, but just a few decades later there was already renewed interest in Murano glass. The mid-1800s saw an invigoration of Murano glass traditions with the foundation of several new firms, including Fratelli Barovier and Fratelli Toso, today Barovier & Toso. Murano glass enjoys a healthy trade today thanks in part to the tourist market and high demand among collectors for special pieces.

Even with the great variety of Murano glass techniques and its long history, there is something cohesive in the visual vocabulary of Murano glass. Even ancient pieces of glass discovered in the Veneto show that the region's glassblowing techniques have remained consistent since ancient times. Some centuries-old museum pieces look remarkably contemporary, with the colorful stripes and swirls we still associate with Murano.

Today, the island of Murano is synonymous with glass. Everything imaginable is made from Murano glass: wine goblets, vases, candlestick holders, miniature animals, paperweights, chandeliers, lampshades, dinner services, tiny pieces of glass candy, beads, and every kind of jewelry you can imagine. There is tremendous variety in quality, price, and style. When it's quickly turned out for a cheap profit among the tourist trade, frankly it can look hideous. When it's well done, it takes your breath away.

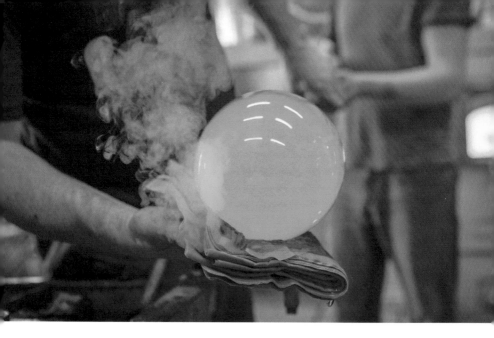

How Murano Glass is Made

For centuries, Murano glassmakers have been masters of experimentation. True to the Venetian interest in reflective materials and saturated color, over the centuries Murano glassmakers experimented with techniques that would impart the shimmering effects and deep contrasts of hues that travelers and collectors still appreciate today. In particular, they developed ways to formulate many shades of red—the color most associated with Venice—from deep burgundy to translucent pink-lavender. Murano glassmakers also played with different combinations of opaque, translucent, and transparent glass.

Glass consists of a paste made with little more than sand, water, and ashes. The main component of glass paste is silica, made from sand or crushed pebbles, which forms about seventy percent of the mix. Sodium carbonate is obtained from the ashes of burned plants. Lime is also added to the mix on Murano, distinguishing it from crystal and lead glass. To create color, cobalt, manganese, and other metallic oxides may be added to the mix.

By the mid-fifteenth century glassmakers had perfected the use of cobalt oxide to produce a deep, sapphire blue; manganese to achieve reddish-purple; tin oxide to produce white; and copper and iron to achieve hues of red so varied and greatly valued that Venetian dialect has not one but many different words for "red."

Traditionally, a glass furnace is a three-story structure with firewood on the ground level, the main oven or crucible in the center, and another furnace at the top that operates at a lower temperature than the one below. The glassblowing process begins when a specialized glass artisan called a gaffer lifts a molten blob from the furnace on the end of a blowpipe. Next, he blows through the mouthpiece, then, twists, pulls, and cuts the shape. The gaffer may also roll or press it against a smooth table surface called a marver. Special tongs and other glassmaking tools forged by a blacksmith are then used to form handles, spouts, stems, and other shapes. The gaffer continues to work the piece until it results in its final form—a goblet, a plate, a vase, or another type of object.

A MURANO TRADEMARK?

Recently an organization called Promovetro / Artistic Glass Murano has brought together glassmakers and others concerned about the influx of cheap replicas crowding the marketplace for Murano glass. They created a trademark that is officially recognized and legally protected under regional law. Participation in the group is voluntary, but many of the Murano glassmakers have joined and actively promote the trademark as a way to guarantee authenticity. Look for the Vetro Artistico® Murano trademark, usually applied as a sticker on individual glass pieces.

Another way to form glass is through lampworking. Lampworking refers simply to the way in which the glass is heated. Instead of heating the mixture in a furnace and blowing glass through a blowpipe, some glassmakers melt the glass using a hand-held torch instead. In past centuries, lampwork was accomplished using a torch or an oil lamp, hence the origin of the name of this technique. Now glassmakers tend to use torches fueled from gas canisters. Lampwork may be used to create any type of vessel or object, and allows for maximum control and intricate detail.

This basic process of glassmaking has remained unchanged for centuries. However, Venetian glassmakers have developed and refined many specialized—and purely Venetian—types of glass, such as the popular flowerlike patterns known as *millefiori*, enameled or incised glass, glass infused with gold leaf, and other works that appear to imitate precious materials such as gems, marble, or chalcedony.

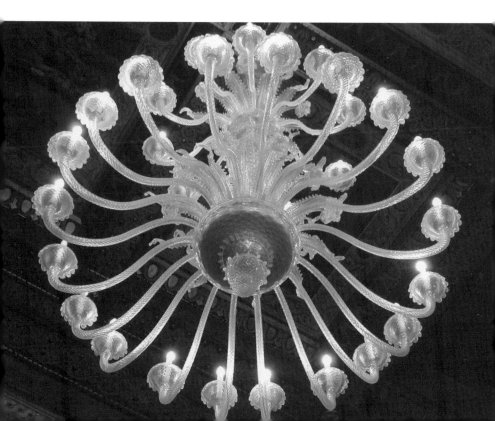

Traditional Types of Murano Glass

It would be easy to fill an entire book with terminology pertaining specifically to Murano glass. Murano glass is an exceptionally complex art with many different techniques and combinations. Without diving too deeply into the minutiae of technique and terminology, here are some of the main types of glass that you will come to recognize if you take the time to have a careful look.

Avventurina

Avventurina refers to colored glass that incorporates iridescent particles, sometimes gold, copper, chrome, or other metals. This process has been used on Murano since the early seventeenth century and is sometimes called *pasta stellaria*, referring to its star-studded appearance.

Filigree (*retortoli* and *reticello*)

Filigree (*filigrana*) involves incorporating narrow rods of glass on the surface of a vessel or as a freestanding work. Creating designs with thin, delicate rods of glass is exceptionally challenging, requiring a high level of patience and skill. The two most common subtypes of filigree are *retortoli* and *reticello*. *Retortoli* filigree has the effect of "twisted" canes of glass, achieved by stretching and rotating the glass as it is heated. *Reticello* refers to a type of decoration incorporated into a glass vessel that gives the effect of lattice or cagework.

Beadwork and jewelry

Murano glass techniques lend themselves naturally to the making of jewelry and beads, and some Murano glassmakers are

specialists in this area. Some of the more accomplished masters pair glass with incised silver and other precious metals.

Murrina and millefiori

The *murrina* technique involves slicing canes of glass to expose transverse patterns, and it can be used to create repeating decorative elements. Glassmakers have made *murrina* since ancient times but Venetian glassmakers developed a renewed interest in it during the Renaissance.

Literally "thousand flowers," *millefiori* is a type of *murrina*. In *millefiori*, the glassmaker slices rods of layered glass to expose a flowerlike design on a clear or light blue disk of glass. *Millefiori* is popular for pendants and earrings, since an individual flower can be isolated for a simple and beautiful effect.

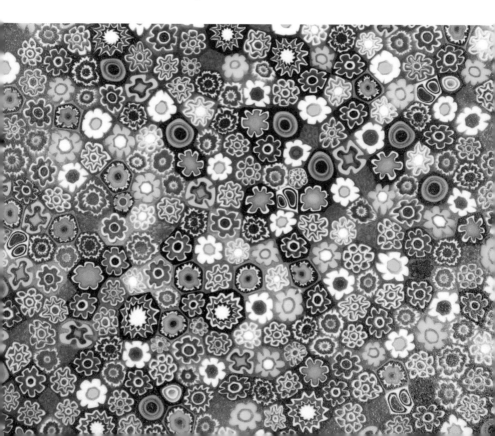

Enameled glass

By the fiteenth century glassmakers finished deeply hued glass pieces, only to embellish them with enamelled colors and gilding applied with paintbrushes. Because the enamelling process requires a second high-temperature firing to seal the colors on the exterior surface, putting the vessel at risk of deforming, it is a particularly challenging technique.

Incised or engraved glass

Incised or engraved glass involves creating a fine-lined figural or decorative design on the glass, an extremely paintstaking art whose effects are particularly beautiful given the delicacy of Venetian glass. Unlike thicker glass from Bohemia and elsewhere, Venetian engravers cannot cut far into the thinly blown glass of Murano; instead, the designs lie right on the surface. Today engravers use diamond-point wheels as well as other tools made with different metals and hard stones to create lines of various widths and levels of opacity.

Mirrors

It is commonly accepted that a Frenchman named Master Robert from Lorraine introduced plate glass to Murano, thanks to a permit from the Venetian government that allowed Master Robert to stay and work on Murano for a period of six months in 1493. In addition to introducing the idea of plate glass to replace leaded bottle glass in windows, plate glass also began to be used for mirrors, replacing the metal ones that Italians used prior to that time. In 1507, the Venetian Council of Ten granted permission for mirrors to be made on Murano. The process involved glassblowers, metal workers who prepared the tin and mercury backing, and a craftsman who fused

the metal and glass to finish the mirror. The art of engraving or incising mirrors continues today, and these ornate mirrors are enjoying renewed vogue among today's interior designers.

Vetro pezzato

In *vetro pezzato* or "pieced glass," large bits of different colored glass are melded together, giving the appearance of a patchwork quilt.

Famous Glassmaking Enterprises

A few of the existing Murano glassmaking enterprises have long-standing traditions. Here are some of the most well-known.

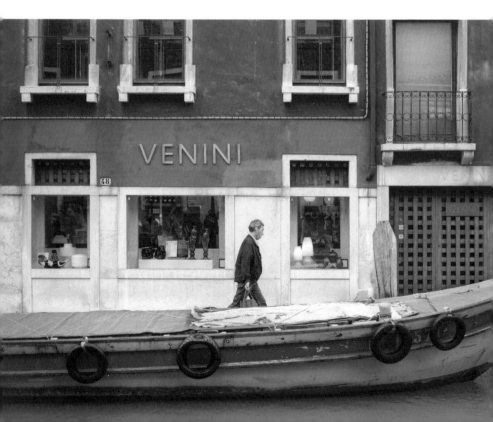

Barovier & Toso

A glassmaker named Angelo Barovier is mentioned in historical documents from Murano starting in the 1420s. His contemporaries credited him with developing several innovations in glass, most notably a particular type of translucent, colorless glass that would come to be called *cristallo*. Even though technically the glass he created is not lead crystal, which would be developed later, Barovier's translucent glass was considered a novelty at the time. Barovier is also mentioned in connection with milk glass, a pure white glass that became popular because it resembled Chinese porcelain. In the 1870s, a family bearing Barovier's name opened a new glassworks on Murano.

The Toso family—Pietro Toso and six sons—founded a furnace on Murano in 1854 and it is now the longest-running glassmaking family on Murano. Today, Barovier & Toso has made a name for itself in the lighting industry, crafting traditional Venetian chandeliers as well as more modern creations. Barovier & Toso has also distinguished itself by offering glass vessels signed by Murano master glassmakers and internationally famous fashion designers.

Ferro

The Ferro family name has been documented on Murano for nearly five hundred years. Today the Ferro family specializes in the production of glass lamps, painstakingly reproducing styles of lighting that decorated some of the Veneto's most prestigious *palazzi*. Each lamp takes its name from the palace that the original came from; some of its more distinctive lamps are in the shape of flowers, candles, and even human figures.

Moretti

Vincenzo Moretti and his sons founded a furnace on Murano in 1900 and enjoyed quick success. Works of the Moretti family are displayed in the Museum of Modern Art in New York and London's Victoria and Albert Museum. The Murano showroom features elegant stemware at steep prices.

Pauly

Founded in 1902, Pauly operates several highly visible glass showrooms in Venice, where it's hard to miss their opulent chandelier displays. In addition to their furnace on Murano, look for their showroom in the Piazza San Marco.

Seguso

Seguso traces its glassmaking roots back to 1300, when the Seguso family is noted in historical documents from Murano. The current business was established in the 1930s. Today, Seguso still stands alongside Venini and Barovier & Toso as one of Murano's most esteemed glassmakers.

Venini

A relative newcomer to Murano, Venini has been in business only since 1921, when Milan lawyer Paolo Venini traded the bench for a career in glassblowing. With him, he brought a Milanese taste for streamlined elegance and refined simplicity. By incorporating this more Milanese flavor, Venini has carved out a distinctive style within the Murano glass tradition.

While many of the big names of Murano glass rely on ostentation and ornateness that is so characteristic of Murano, Venini creates works of more understated elegance and modern sophistication. Venini is credited with developing the popular *fazzoletto* vases designed to look like folded tissues.

How to Buy Murano Glass

It's worth the trip to Murano to watch molten glass on the end of a rod be transformed as if by magic into gorgeous vases, glasses, and candlesticks before your eyes. Chances are you'll arrive at the boat ramp on the south end of the island of Murano. When you disembark, move away from the area as quickly as possible, as hawkers may lure you into one of the more touristy glass factories bordering the docks that sell lower quality goods for higher prices. Instead, head toward the glass museum and window shop along the way. The farther north you walk toward the museum and the Basilica of Santi Maria e Donato, the more the prices fall.

BUYER BEWARE

Chances are a persistent hawker hanging around San Marco will offer you a boat trip and an "exclusive" glass factory tour on Murano. The truth is that it only costs a small fee to take the ferry to the island yourself, and once there, you will be free to visit any glassmakers you want on your own. Best of all, you'll avoid the high-pressure sales tactics and be able to enjoy the highlights of this quiet, beautiful, and special island free of distraction.

The range of quality and price on Murano is staggering. Be prepared to see everything from silly figurines of Donald Duck to drop-dead gorgeous tableware with so many zeros on the price tag that it will make your head spin. In order to make sense of it all, the wonderful glass museum should be the first stop on your trip to Murano. You may be inclined or encouraged to head straight to the glass factories, but insist on visiting the museum first. There you will have the chance to train your eye.

The glass museum contains works of Murano glass from ancient times to the present, including an incredible glass centerpiece made for what must have been an enormous dining table in the Palazzo Morosini in the 1700s. The intricate ensemble resembles a garden complete with glass shrubs, vases, and fountains. After viewing this impressive collection of glass from the Roman era to the present, it's hard to imagine that today's glass artists could come up with anything new. However, styles evolve, and rest assured that you'll emerge from the museum with plenty left to see in the shops.

In addition to the glass museum, a tour of one or more of the glass factories is the main attraction on Murano. Even if you don't buy there, it's worth the trip to see the impressive glass-blowing demonstrations. You can catch a factory tour just by showing up during open hours (most remain open during the sacred Italian lunch hour). Don't feel obliged to buy as the crowd funnels into the factory shop. There is much to see on Murano and you'll find many more buying opportunities.

Some glassmakers are set up to pack and ship your treasures home and can usually ship anywhere in the world. Many of them have special packing materials and containers designed for protecting glassware. Still, shipping delicate pieces home can prove both costly and hazardous. If you decide to ship, don't forget to get the seller's email address, get the tracking number, and insure, insure, insure.

Don't leave Murano without visiting the Basilica of Santi Maria e Donato. This beautiful church contains a treasure—a twelfth-century floor mosaic with images of birds and other creatures, all crafted from shards of Murano glass.

HOW MUCH TO PAY

Prices for Murano glass vary according to three main factors:

- The techniques used to execute the piece. You'll pay more for more threads (the colored bands of glass swirled into a finished piece) and intricate designs.

- The repute of the maker. Some glass houses— especially Barovier & Toso, Moretti, Pauly, Seguso and Venini—command higher prices than others because of the quality of their work and the long tradition behind their names.

- If the piece is designed or signed by a big-name designer. Recently well-known fashion designers have designed pieces for some of the top glass producers, and you will pay a premium for signed pieces.

Finally, if you buy an antique, either on Murano or elsewhere, you must take into account not only all of the above, but also the condition and provenance (the documented history) of the piece. The highest valued Murano glass works may fetch six figures at auction.

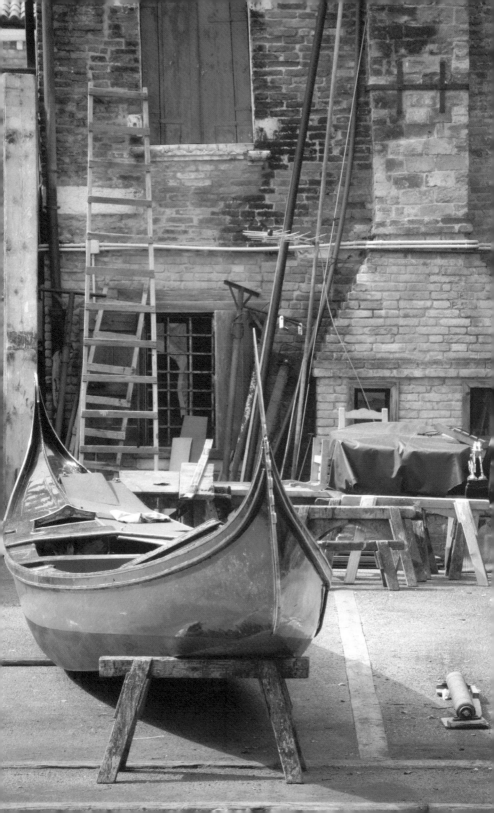

3

Gondolas

In the heyday of the Venetian Republic, some ten thousand gondolas transported dignitaries, merchants, and goods through the crowded canals and lagoons of the water-logged city. Today, only about four hundred *gondole* glide through the waterways of Venice. Across the city and the outlying islands, a handful of boatyards or *squeri* still make and repair gondolas using modern techniques and power tools, but each year, fewer and fewer authentic gondolas are turned out by hand. A small group of specialized master boat builders working in historic boatyards now holds the craft—literally—in its hands.

Although the gondola has become the symbol of Venice, the city once teemed with diverse types of handmade wooden boats, from utilitarian rafts to canal ferries to the famous Venetian war galleys—which the government bragged its craftsmen could rig in a single day—and the doge's own impossibly ornate, gilded barge, the Bucintoro. That's not surprising when you realize that Venetians have long relied on boats for transporting everything.

The Venetian gondola began as a much simpler contraption than the elaborate boats now synonymous with Venice. To my knowledge no complete Venetian gondola made prior to the mid-1800s survives intact; only a handful of iron prows from the

Renaissance era have endured the humid Venetian climate that destroys anything made of wood, even of the highest order of craftsmanship.

The earliest documentary evidence of the Venetian gondola dates to 1094, when the word *gondolum* is used in a letter from the Doge, Vitale Falier, to the people of Loreo. We must wait another four hundred years for visual evidence of the distinctive boat. The earliest depictions of the Venetian gondola let us imagine what these early boats might have looked like. We can envision these dark, elegant boats with the help of a series of beautiful wall paintings executed by Vittore Carpaccio in the 1490s for the Church of Saint Ursula, now preserved in the Accademia in Venice. In this cycle of paintings, gondoliers appear to maneuver their boats using the oarlock, a manner of rowing that is not too different than that of today.

Not only Venetians but also foreign visitors must have been impressed by these distinctive boats, since printmakers such as the Swiss artist Joseph Heinz the Younger and the Dutch author and statesman Nicolaes Witsens disseminated views of the gondola in woodcut prints and engravings that made their way across Europe. A woodcut by the Swiss artist Jost Amman portrays a gondola with a fore and aft oarlock, rowed by two oarsmen, in "Grand Procession of the Doge of Venice," published in Frankfurt in 1597. A sketchy carving on an altarpiece erected by gondola makers in 1628 inside the Church of San Trovaso depicts the familiar arc of the gondola with its spiky iron prow decorations, the *ferri*, on either end, and a covered passenger compartment, or *felze*.

More elaborate oarlocks, upholstery, carving, and the peculiar asymmetrical form of modern gondolas, which allows for more effective rowing, all developed from the 1700s onward. Since the late 1800s, gondola makers have made the left side of the boat wider than the right, giving the correct counterbalance to the force created by a single gondolier and allowing him to row

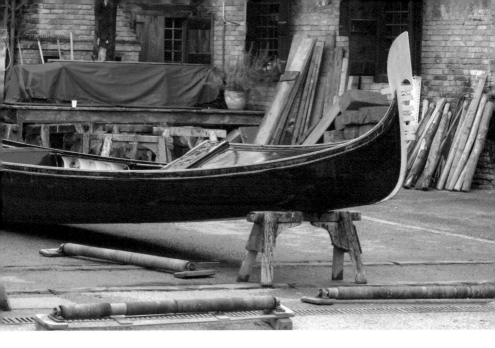

through crowded spaces only from the right side, and without lifting his oar from the water.

From the beginning, members of the boat-making guilds abided by a set of strict social codes as well as an impressive body of written rules called the *mariregole*. These rules governed integral aspects of the boat makers' lives: everything from regulating their apprentices and salaries to dowering their daughters, ministering to their sick, providing for their retired, and burying their dead. Above all, it was expected that a son would follow in his father's footsteps, and pass the torch of the gondola-building traditions of the family *squero* to the next generation.

Much like a modern-day taxi system, many gondolas were leased to boatmen who serviced the ferry stations, or *traghetti*, that dotted the canals. Even though Venetian boatmen once numbered in the tens of thousands, because they were members of the lower class they remain relatively silent in historical documents except for random incidental accounts, many of which involve infractions that took place in gondolas, including cursing, gambling, extorting passengers, or worse.

THE *SQUERO*

The famous "Barbari map," an enormous woodcut by Jacopo de Barbari dating from 1500, shows an aerial view of Venice that gives us an appreciation of the huge number of boatyards, or *squeri*, in the city at that time. No longer used as boatyards, most of these historic *squeri* have become residences, storage facilities, and commercial spaces. However, if you know how to spot the characteristic features of the *squero*—the boathouse open to the canal, and the ramp leading gradually into the waters—you'll begin to recognize these disused *squeri* all over town. The best way to appreciate them is by boat. Look for them along the waterways of Cannaregio and Dorsoduro, and also along the Zattere.

Wealthy Venetians owned one or more of their own private gondolas, and they employed their own boatmen as part of their servant staff to maintain their boats, dock them in private boathouses, and remain at their masters' disposal to ferry them around the city. Eventually, the gondola became a status symbol much like an expensive car, with custom fittings, elaborately carved and sometimes gilded ornamentation, and seasonal fabrics such as silk and velvet. Even after 1562, when authorities banned what was seen as sinfully ostentatious ornamentation and decreed that all but ceremonial gondolas be painted black, some wealthy Venetians chose to pay the fines, a small price to keep up appearances.

How Gondolas Are Made

Traditionally, the craft of the *squerariólo* begins with a wooden frame or template called a *cantier*, which may have been hammered into the dirt floor of the workspace generations earlier. From this basic form, the gondola builder may attach the fore and aft sterns to the wooden frame, then form the longitudinal planks and ribs that make up the frame of the boat.

Nine different kinds of wood—beech, cherry, elm, fir, larch, lime, mahogany, oak, and walnut—are shaped to form the distinctive boat designed to glide through shallow water. The oak is the most critical, for the planks run the entire length of the boat (about thirty feet). Originally, wood was delivered to Venetian boatyards by river from the Dolomite Mountains in the northern part of the Veneto region. The wood was left to season, sometimes for years, before the gondola maker deemed it ready to use for boat construction.

WHERE TO SEE GONDOLAS BEING MADE

Today's remaining gondola makers and artisans in related trades cluster in the quiet section of town known as Dorsoduro, with a few more scattered across the other *sestieri* of Venice and its outlying islands. Visiting these workshops is not the same as visiting a museum or even, let's say, a mask-maker's shop or a glass-making factory, where you are much more likely to leave with a souvenir. It is important to contact them in advance and be respectful of the artisans' time and the important work they are doing to preserve Venice's maritime history.

LOOK FOR A SIGN

As you wend your way through the narrow alleys of Venice, keep your eyes out for street signs that recall the historic locations of gondola-makers and their related tradesmen. Many street names in Venice contain the words *squero, squeri, remer, felzi,* or *traghetto* (ferry station), a potent reminder of the boatbuilding trades that once kept life in the Most Serene Republic gliding along at a steady clip.

A gondola has no straight lines or edges. Its distinctive warped profile results from an impressive fire-and-water process that involves shaping the boards with torches made of marsh reeds set ablaze. Once the basic shape has been achieved, gondola makers reinforce the craft by attaching longitudinal cap rails, then fore and aft decks made of mahogany and larch. Finally, the boat is flipped bottom-up, and the keel is planked and varnished.

The majority of the hours in gondola-building go into the final stages: finishing the elaborate trim-work, then preparing surfaces and applying multiple coats of varnish to make the boat watertight. After some five hundred hours of labor, the boat slides down the ramp of the *squero* and into the canal.

Gondola Fittings

Across the city, a cadre of specialized artisans—ironsmiths, upholsterers, and makers of everything from oarlocks to hats—supplied their gondola-making colleagues with elaborate passenger compartments (*felzi*), engraved prow and stern forks (*ferri*), row locks, oars, upholstery, and other ornaments of steel and brass. Today, a handful of master craftsmen carry on these traditions.

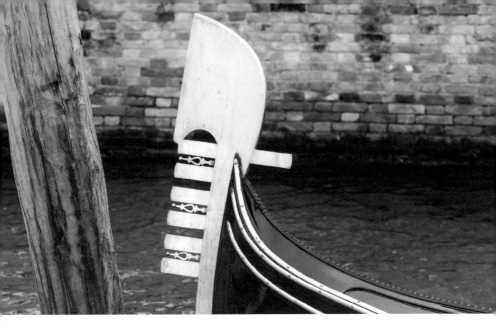

Prow and stern forks (*ferri*)

The earliest gondolas were probably little ornamented, but by the sixteenth century, decorative ironwork on the prow and stern became more common. Originally pronged forks decorated both the prow and stern, and were made of iron, as the name *ferro* suggests. Some were more elaborate than others, with fanciful swirling forms or engraved decoration.

Today, it is more common to see a larger fork on the prow, where it counterbalances the weight of the gondolier. The stern fork is typically smaller or omitted altogether. The lore of the six-pronged *ferro* as a symbol of the city's six neighborhoods, or *sestieri*, is a wonderful story but one without any historical basis.

Passenger compartments (*felzi*)

Up until relatively recent times, passenger gondolas were constructed with a covered compartment called a *felso* in Venetian dialect. These compartments were sometimes heavily

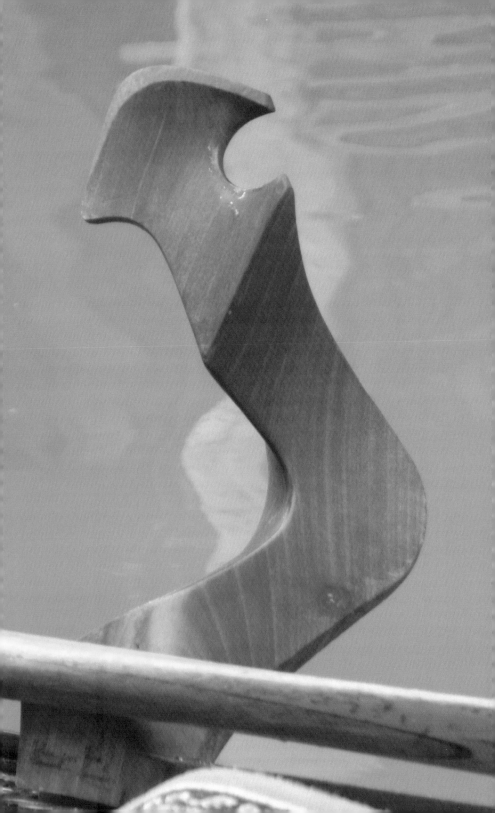

ornamented with woodcarving and embellished with seasonal fabrics to protect passengers from rain, heat, and cold. *Felzi* were abandoned only in the twentieth century, given that open gondolas were more accommodating for tourist sightseers rather than for private citizens who wished to protect their privacy. The result is that today's boats no longer retain the old silhouette of the traditional gondola.

Oars and oarlocks (*remi* e *fórcole*)

Makers of oars (*remi*) and oarlocks (*fórcole*) were integral partners to the gondola makers, as steering a gondola in tight, crowded canals without the characteristic oarlock would be nearly impossible. Originally a simple wooden fork, the Venetian *fórcola* evolved over the centuries into a complex, high-precision instrument that allows the gondolier to maneuver the single oar into countless different positions without removing the oar from the water, thus easily navigating narrow, crowded canals by rowing from a single side of the boat. *Fórcola* makers, or *remeri*, developed as specialized craftspeople apart from the other trades.

Its elegant sculptural form is deceiving, for the oarlock is pure function. There are five main positions for the oar; they help the rower start, stop, accelerate, turn right or left, and slow the gondola. Rowing is considered a specialized skill in the Veneto, and many heated competitions take place each year, awarding prizes to competitive rowers.

Today some connoisseurs collect and display these elegant sculptural works as standalone art objects. The remaining *remeri* follow traditional methods of carving Venetian oarlocks from seasoned trunks of walnut, cherry, or pear wood, releasing their curvilinear forms and polishing the finished pieces to a high sheen. You can purchase a small-scale model of an authentic *fórcola* or spend much more for a larger-than-life *fórcola* sculpture to display in your home or garden.

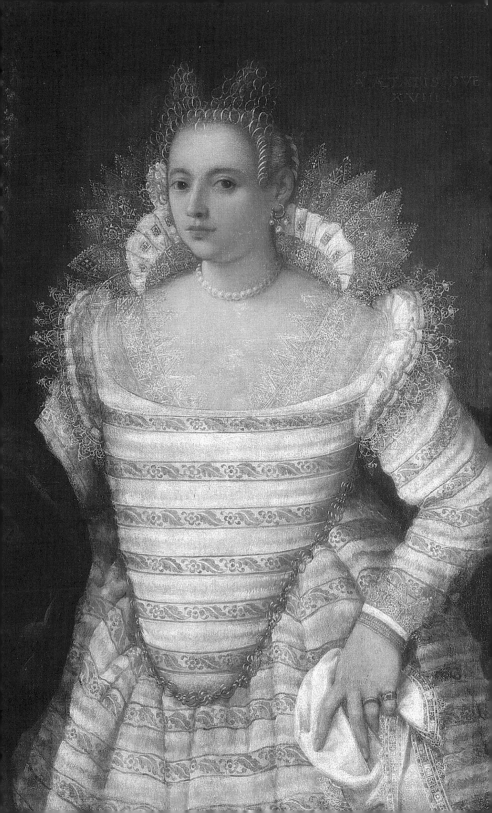

4

Lace

I n 1880, twenty-four of the thirty inpatients at the women-only San Clemente "lunatic asylum" in Venice were listed on the books as lacemakers. Whether a coincidence or a measure of the long-lasting effects of such tedious work, one thing is certain: creating traditional Venetian lace is one of the most painstaking endeavors in the history of art.

The origins of Venetian lace are lost to history. According to legend, a love-struck sailor gave a Venetian girl an aquatic plant called *trina delle sirene*—mermaid's lace. The girl was so taken with it that she immortalized its beautiful form with fine threads, and the art of lacemaking was born. Over several centuries, Venetian lacemakers produced wonders of breathtaking intricacy, extremely fine pieces stitched together with gossamer-fine threads. For three hundred years their work boasted the most prestigious lace pedigree in Italy, if not in the world.

The earliest Venetian laces were produced inside convents and were reserved for church vestments, altar cloths, and other delicate church finery. Trade guilds also began to craft lace in the fifteenth and sixteenth centuries, although in Venice—as in other important lace cities in northern France and Flanders— the convents continued to be prolific centers of lace production.

Because lace was considered a proper task for a woman, especially one dedicated to contemplative life, many cloistered women spent most of their daylight hours—indeed most of their lives—with a needle and thread. Lacemaking also became the province of the various *scuole*, or Venetian civic organizations, which, among other charitable activities, organized work for victims of circumstance, including spinsters, orphans, and others who could not find a clear place within the strict social roles of Venetian society.

The heyday of Venetian needle lace ranged from about 1620 to 1710, the height of demand among European nobility and royalty. Venetian lace became known as *punto in aria* or "points in the air" because of its delicate effects. At that time, fashion called for lace collars and cuffs, as well as handkerchiefs and other accessories for both men and women. A type of lace collar that spread out in a fan behind a woman's head became popular in Venice itself.

Venetian lace gained such fame that it became a status symbol for European nobles. Portraits of nobles wearing outlandishly fancy lace collars—the kinds you see in the seventeenth-century paintings of Rembrandt and van Dyck—helped make Venetian lace a status symbol among aristocracy from Ghent to Paris. European nobles wore their Venetian lace finery to sit for portraits that would be handed down to future generations. Painters were challenged to capture the web-like intricacies of lace in paint, portraying their sitters' collars, cuffs, shawls, veils, and gloves.

A PAINSTAKING ART

Apart from the beauty and fame of Venetian lace, the main thing to appreciate is how extraordinarily painstaking it is to make. A small, seventeenth-century lace cap now in the Lacis Museum of Lace and Textiles in California boasts some 10,000 stitches per square inch, and probably took some five years to produce.

Venetian lace is well documented among the most prized possessions of European nobles. In the 1600s, an inventory of the wardrobe of Elizabeth I of England included lace of "Venice sylver" and "Venys gold," a testament to the practice of weaving braids of precious metals into lace patterns for costly fine garments. *Punto in aria* is also well documented throughout the Renaissance as part of women's dowry inventories, a testament to its enduring value.

In order to supply the increasing demand for Venetian lace, cloth merchants moved lace production to the outlying lagoon islands in order to employ lacemakers at low cost. Soon, lace produced on the island of Burano became the most highly coveted lace in Europe. The women began working in almost an assembly-line fashion, churning out trimmings and finery to supply the clothiers' guild. Although the lacemakers themselves never became wealthy, those involved in the international trade of lace and textiles could soon afford to occupy the finest palaces of Venice.

Catherine de Medici, an Italian noblewoman who became Queen of France, brought Venetian lace designers to the French court in the mid-1500s, and *punto in aria* remained popular in France for another two centuries. King Louis XIV looked to Venetian artists rather than French ones when it came time for his coronation in 1654. For the event, he wore a fine lace collar that took lacemakers Lucretia and Vittoria Torre from the hospice of the Zitelle on Giudecca some two years to produce. The commission created renewed demand among French patrons, and in 1665, Jean-Baptiste Colbert, the French Minister of Finance, brought a group of Venetian lacemakers to train women in the French lace-making centers of Reims and Alençon.

Eventually, the rise of French and Flemish centers of production signaled the end of an era for Venetian lace. By the end of the seventeenth century, stiff competition with these northern rivals caused the Venetian lace industry to decline, even though Burano

lacemakers attempted to evolve along with fashions. French needle lace, *point de France*, rose in popularity, and Venetian lacemakers began to borrow French motifs. When collars made with Flemish bobbin lace became all the rage in the eighteenth century, Venetian lacemakers emulated it with the needle and thread, resulting in a new type of lace that came to be known as *punto Burano.*

As Venetian lace began to fall from favor, there were attempts to found a lacemaking school on Burano to revive what was already seen as a waning tradition. However, by the end of the eighteenth century, in the wake of the French and American Revolutions, people no longer wanted to wear fashions that were associated with the reviled aristocracy.

HOW LACE CAST A WIDE NET

Venice was a capital of European bookmaking, and by the sixteenth century, Venetian engravers and printers were producing lace pattern books that were widely disseminated across the continent. A significant percentage of the lace pattern books produced during the sixteenth century were made in Venice. Based on the books' dedications, we know that many of these books were destined for noble households occupied by women for whom formal education and labor were not an option but for whom lacemaking was considered an appropriate pursuit. Many of the pieces these women made— table linens, for example—would have been destined to adorn the richly appointed households of the increasingly wealthy patrician and merchant classes of Renaissance Europe.

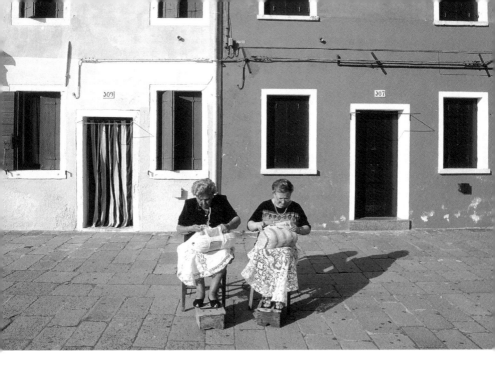

On Burano, however, lacemaking never truly died, as mothers continued to pass on the tradition and the skill to their daughters and granddaughters. The art of Venetian lacemaking ceased large-scale production and returned to its origins as a private, domestic occupation. Many women turned to bobbin lace, a faster and therefore more economical technique for turning out edgings for table linens and other accessories.

Venetian lace enjoyed a revival toward the end of the 1800s, thanks in part to the politician Paolo Fambri, who gathered the right group of people and resources to bolster Burano's sagging economy and bring the tradition of lace to life again. A small group of supporters rallied around a vision to revive the tradition of Venetian needle lace, as well as other bobbin lace traditions once practiced widely in the Veneto region, particularly in Pellestrina and Chioggia. At that time, a single elderly, illiterate woman named Cencia Scarpariola remembered how to execute the centuries-old *punto in aria di Burano* stitch, which she passed on to several other women.

In 1872, the Scuola di Merletti, or lace school, opened thanks to the patronage of Countess Adriana Marcello, Princess Margherita of Savoy, and several other noblewomen who agreed to purchase the work produced by the school. Fambri also brought together several companies to begin producing and selling traditional lace. One of these companies belonged to a Venetian entrepreneur named Michelangelo Jesurum. Mr. Jesurum opened a lacemaking factory, which helped to pass the torch of tradition. In 1939, the business was sold to the Levi Morenos family, who continues to operate the enterprise under the name Jesurum today.

Many of the women you see on Burano today making lace in the squares and on the sidewalks learned the craft from childhood, either from their mothers or grandmothers, or from the old lacemaking school. The craft continues thanks to today's lively Venetian tourist trade, which still supplies buyers for this long-standing art form.

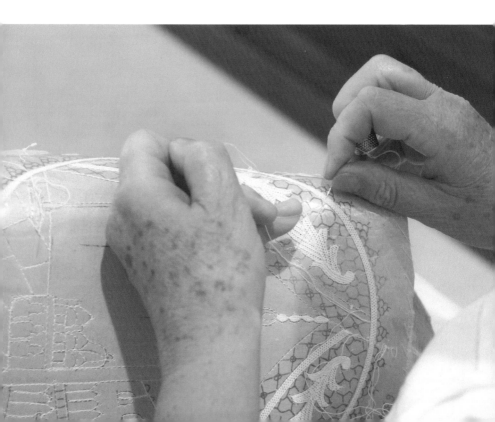

How Venetian Lace is Made

There are two main types of handmade lace: needle or point lace, and bobbin or pillow lace. In the Veneto, needle lace prevails, made with a single needle and thread, although bobbin lace is also produced, both in Venice and on the mainland. A third type of lace known as filet lace is also produced, especially in Chioggia, and involves embroidering designs using a long, flat needle on top of a lace net.

Traditionally, Venetian *punto in aria* is made with a single needle and linen thread. Designs are built stitch by stitch, requiring hours of work to produce mere centimeters of finished lace. As in past centuries, most lacemakers work from pattern books. The lacemaker traces or draws the design onto parchment, then fastens it to a piece of linen for support, using basting stitches. Each woman typically secures the design on a special pillow called a *cussinello*, which rests on her lap, sometimes with a small drawer for needles, thread, scissors, and thimbles.

A mesh or net background—referred to by the French term *réseau*, meaning "network"—forms the field for design elements in lace. Lace specialists can often identify the origin of the lace based on the type of *réseau*. For Burano, the *réseau* resembles ladders stacked side by side, each bar stitched meticulously one by one.

Once the background is established, the lacemaker may work the interstices of the pattern. Buttonhole stitches form the basis of many of the main designs. Other decorative elements may be added with picot or other special stitches to add raised work to the design. Once finished, the underlying linen is cut free from the completed piece of lace.

Because traditional lace is so time-consuming, the lacemakers of today use a hybrid method of machine-sewn backing with some handmade finishes. The piece begins with a pattern, a template on parchment-thin paper, which is then slowly

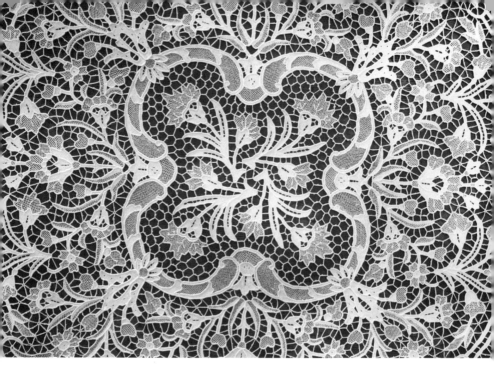

and carefully hand-sewn onto a piece of fabric using a sewing machine. Next, the piece passes through the hands of several different women, each responsible for one type of finishing stitch or design—swirls, rosettes, and so on.

Even using this more modern hybrid technique, a piece smaller than a placemat may still take two to three months to produce and can be expensive. Most pieces end up framed or in other types of displays because they are too precious to use in everyday life.

Historical Venetian Lace Designs

Based on design, techniques, and style, lace experts can pinpoint the origin of lace with remarkable precision. Historic Venetian lace distinguishes itself from lace from the other European lace capitals (Alençon, Bruges, Lille, Antwerp, Brussels, and Lyon) by its intricacy, microscopic details, and extreme finery.

Needle lace tends to be crisper and stiffer than bobbin lace, which is more flexible because it is woven by swiftly moving threads that are wound around bobbins. Most traditional Venetian lace patterns rely on geometric forms such as circles, stars, rosettes, and triangles. Animals, flowers, scrolls, and other naturalistic elements may play a part in fancier designs.

Sixteenth-century designs

Laces from this period are usually based on a grid of regularly spaced, repeating decorative elements such as rosettes. Many of the pieces that survive from this era have been preserved in church treasuries.

Seventeenth-century designs

By the early seventeenth century, lacemakers began to abandon the grid format in favor of more freeform designs. Some of the Venetian designs of this period are a breathtaking maze of ornamentation. The lace of this period is notable for its highly defined scrolls and tendrils, which you will see not only in the lace itself but also replicated in paint in seventeenth-century portraits.

Eighteenth-century designs

Fashions evolved to favor solid, dark-colored clothing for both men and women, so lace had a chance to take center stage with ostentatious collars and cuffs, some woven with gold or silver threads. The most popular type of Venetian lace at this time was *gros point de Venise*, a complicated stitch that is based on floral elements and raised work.

How to Buy Venetian Lace

The peaceful island of Burano is the undisputed capital of Italian lace history. A 45-minute boat ride from the Piazza San Marco, Burano is worth the trip to see lacemakers work their magic. Today, Burano is known for its quiet alleys, its brightly painted houses, its picturesque fishing boats, and its lace shops selling everything from doilies, tablecloths, babies' baptismal gowns, jewelry, and many other knickknacks.

You should understand that purely handmade lace is extremely rare today. Much of the lace on Burano is made using the hybrid technique described above, relying on machine-sewn designs with hand finishing. The island's shops also sell many pieces that are exclusively machine-made. Beware: some of these are not made on Burano at all.

Lacemaking machines weave cotton thread many times faster than the human hand. By contrast, even a small finished piece of handmade needle lace can take weeks to craft. Therefore, the price for handmade lace is typically many times more than a machine-made version of the same kind of work. Today's labor prices make handmade work cost-prohibitive except for expensive custom work on a small scale or hand-finished details on a machine-made piece.

Even for machine-made lace, however, quality may vary widely. The easiest way to recognize a lower-quality piece of machine-made lace is that the stitches appear extremely tight and the finished product feels stiff. The designs are so flawless that only a machine could have made them, giving an overall sterile and lifeless effect. By contrast, handmade laces are delicate and contain imperfections only the human hand could create. However, some machine-made lace is so fine that it is difficult even for experts to tell the difference.

PRICE POINT

Genuine, handmade lace from Burano should cost at least ten times more than its machine-made counterpart, based on the number of hours that go into its making.

The old lace school on Burano closed in 1961 after a series of financial difficulties, but a Lace Museum was formed in 1981 and it now occupies two former gothic palaces. The museum should be your first stop on Burano, as you can usually watch lace-makers working there firsthand. Before buying, it's important to view authentic Venetian lace from past centuries. The collection includes a rotating exhibition of several hundred authentic pieces, so it's a great place to train your eye.

If you have your heart set on handmade lace, you can commission a company such as Jesurum or an individual lace-maker to craft a custom work for you. Keep in mind that these will be small works. A large piece could take years or longer to craft entirely by hand, and would command a tremendous price.

It's a good idea to buy from the museum shop or directly from one of the lacemakers you may see gathered outside, working a pattern with needle and thread. Venice is one of the most tour-ist-trap-filled cities in the world, so always buy from a reputable source and be careful that you're not paying an exorbitant price for a hastily made piece that may have been fabricated elsewhere.

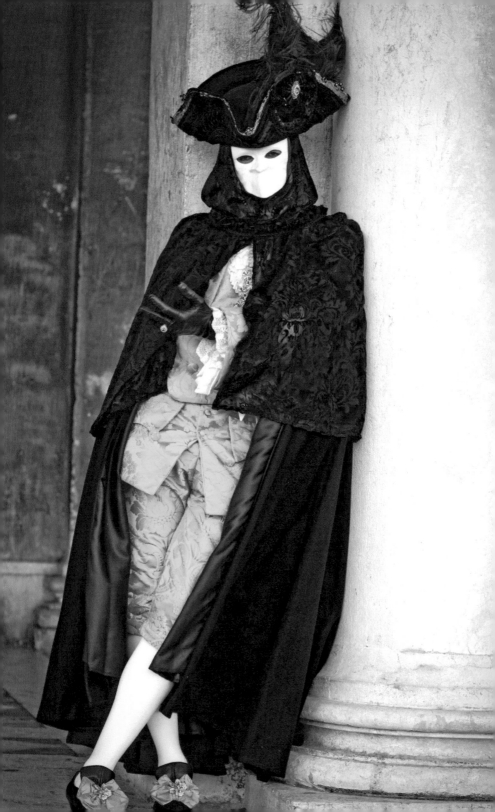

5

Masks

No one knows exactly when, how, or why Venetians began to wear masks in public. Some historians attribute the origin of masquerade celebrations to festivities surrounding the Venetian Republic's conquest of lands in the eastern Mediterranean, but there is little evidence to help us understand the original motivations behind this curious tradition.

The earliest accounts of Venetian masks are laws stating what Venetians could *not* do while wearing one. A law of 1268 forbade masked people from playing certain games. Another thirteenth-century law prohibited masked people from gambling. In 1339, the Republic's lawmakers specifically outlawed vulgar disguises and visiting convents while wearing a mask. As is the case with all laws, we can only assume that they existed because people were doing whatever was forbidden.

During the Middle Ages, Venetian mask makers (singular *mascarer* or plural *mascareri*) were organized into guilds or *arti*. Their statutes, recorded in 1436, placed mask makers under the same regulations as painters. The statutes set forth strict rules about the education and advancement of apprentices and journeymen, and stipulated the conditions under which masks could be produced and sold in the city.

From these medieval accounts, we learn that masks were associated with Venetian Carnival. Carnival is a traditional annual festival in Catholic countries that takes place during the ten days leading up to Lent. Lent being a time of abstinence (the origin of the word *carnival* is thought to connote "relief from meat"), the days leading up to it entailed the opposite: overindulgence in food, drink, and merry-making. The city held its first Carnival in the eleventh century. Carnival celebrations extended through the city streets and squares, with dancers, acrobats, jesters, and other street entertainers. This free-for-all celebration included parades, balls, practical jokes, street music, and general revelry.

Under the laws of the Republic, Venetians were allowed to wear masks starting with Santo Stefano on December 26 and leading up to the beginning of Carnival on Shrove Tuesday (also called Fat Tuesday), which usually falls in February. In these early centuries, the official period of mask wearing was the one time of year when social divisions were blurred; behind the mask it was impossible to tell aristocracy from the lower classes. Scholars believe that mask wearing allowed people some relief from the rigidity of Venetian class divisions. By the seventeenth century, Carnival celebrations were not the only setting for the wearing of masks. Venetians also wore masks during state ceremonies, at society balls, at opera and theater performances, and at other public events.

While today we think of Venetian Carnival masks as opulent, even ostentatious, the early ones were simple affairs, little more than unadorned faceplates of white or black. By the time Venetian Carnival reached it zenith in the sixteenth century, masks had become more elaborate along with the costumes and jewelry for which Venetians were world-renowned. In fact, masks are inextricably linked to the history of costume in Venice. In the sixteenth and seventeenth centuries, costume renters ran successful businesses, outfitting their clients with sumptuous fabrics adorned with tassels, trims, beads, feathers, ruffles, jewels, pearls, and

MASKED MEN

Specific laws governed the wearing and use of the *baùta*, a standard Venetian mask worn within the context of Venetian government. The *baùta* could be worn only by Venetian citizens and at times of significant political and law-making events when it was important for people to remain anonymous in the interest of fair decision-making. In this interesting turn of events, what started out as a practice to turn societal structure on its head, instead ended up sustaining it.

other finery. As the theater genre of the Commedia dell'Arte gained popularity, many Venetian masks emulated popular characters from the stage.

When the Republic fell at the end of the eighteenth century, the ruling king of Austria outlawed Carnival celebrations in Venice, specifically banning the wearing of masks. The art of Venetian mask making fell into a lull until Carnival was revived in the late 1970s; the efforts of just a few local mask makers renewed the tradition. At that time, the Italian government sought to boost tourism and made the Carnevale di Venezia the focus of their efforts. The number of mask makers grew quickly, and today there is a group of notable mask makers carrying on the traditional techniques.

Today, it is nearly impossible to find a street in Venice without at least one shop selling masks. At Carnival time, several private balls including the exclusive Ballo del Doge cater to dignitaries who want to recreate the magic of Venetian Carnival, including the wearing of traditional masks. The Venetian Carnival attracts hordes of international visitors, and the tradition of mask making continues in part thanks to today's lively Venetian tourist trade.

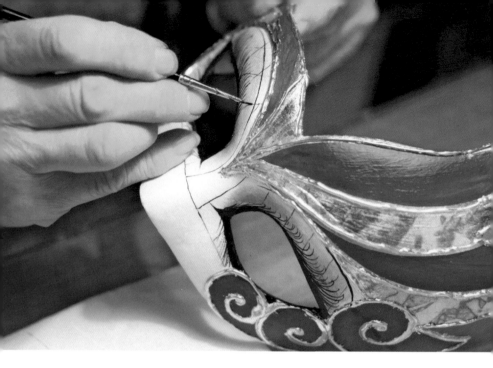

How Venetian Masks Are Made

Early Venetian *mascareri* used a variety of materials, from waxed cloth to canvas, velvet, lace, leather, and papier-mâché. Today, a few mask makers craft masks using leather, glass, and even ceramic. However, the mask makers adhering most closely to authentic, traditional Venetian mask types work primarily in papier-mâché.

Today, most traditional masks begin with a clay form that may be used to make a plaster cast. The clay or plaster model may be used again and again to form the basic mask, even though no two masks end up looking exactly the same. The *mascarer* presses wet paper pulp over the clay form, then leaves it to air-dry. Once dry, the paper will retain the shape of the cast or clay model. Next, the mask maker buffs the mask and cuts holes for the eyes and other facial features, if desired. Finally, the mask is painted by hand using tempera paints. Most mask makers have a variety of paintbrushes at their workbenches, using fine brushes for gilding and other details. Some complete a piece by covering it with wax,

gloss, or polish to impart a shiny finish, but these trade secrets vary from workshop to workshop.

Traditional Mask Types

Although the earliest Venetian Carnival masks were simple affairs—a plain white or black molded form with cutouts for the eyes—eventually a range of archetypal masks developed. By the eighteenth century, some of the most commonly worn mask types were based on characters from the Commedia dell'Arte, a popular theater genre whose stock characters would have been immediately recognizable to an eighteenth-century Venetian. These characters included a host of heroes, clowns, patricians, and servants. Most of the masks based on these stage characters were half-masks, since the mouth needed to remain free so that the actor could be heard.

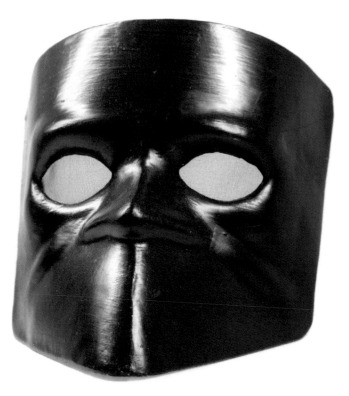

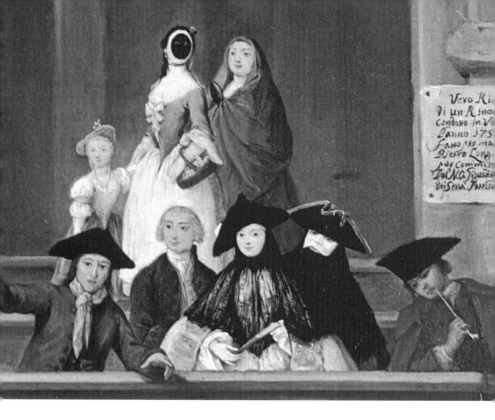

The *baùta* or *baùtta*

The *baùta* is the quintessential Venetian mask, worn historically not only at Carnival time but any time a Venetian citizen wished to remain anonymous, such as when he may have been involved in important law-making or political processes in the city. The simplest of the traditional Venetian mask types, the *baùta* is a stark faceplate traditionally paired with a full-length black or red hooded cloak called a *tabàro* (or *tabàrro*), and a tricorn hat, as depicted in paintings and prints by the Venetian artist Pietro Longhi.

Most *baùte* were made of waxed papier-mâché and covered most of the face. The most prominent feature is a distinctive aquiline nose and no mouth. The lower part of the mask protruded outward to allow the mask wearer to breathe, talk, and eat while remaining disguised.

The *moretta*

The *moretta* is thought to be of French origin, but it became a popular women's mask in Venice by the seventeenth century. Usually made of black velvet, the *moretta* consisted of a simple, oval faceplate with cutouts for the eyes but not the nose or mouth. Women secured the mask to their faces by holding a button on the inside of the *moretta* between their teeth! Understandably, the popularity of this mask was short-lived.

The *volto*

The *volto* is meant to be a generic face in the crowd; the word *volto* means "face" in Italian. The *volto* consists of a simple, white oval with cutouts for the eyes and nose. Traditionally, the *volto* was worn by Venetian citizens at Carnival time and for important feast days and events, complemented by more individualized costumes.

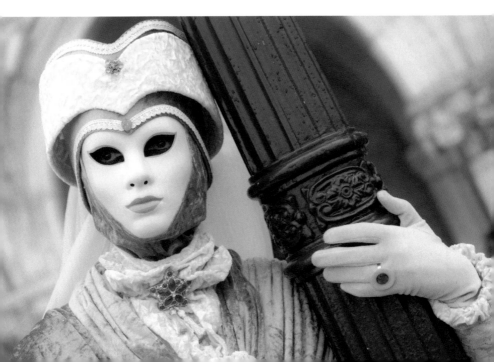

Commedia dell'Arte Masks

The Commedia dell'Arte emerged as a theater style in Italy in the second half of the sixteenth century, and enjoyed enormous popularity over the next two centuries. The lively stage productions took place in temporary outdoor venues, and featured humorous sketches based on stereotypical, stock characters whose roles stayed consistent even though the stories changed. Audiences recognized these stock social types as parodies of characters from various walks of life. The Commedia dell'Arte found its perfect audience among Venetians, with their love of public spectacle, costumes, and masks.

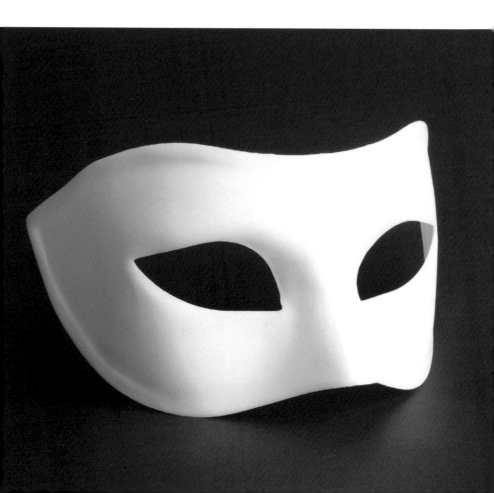

Colombina

In the Commedia dell'Arte, Colombina played the role of maid-servant. The Colombina is a half-mask that covers the forehead down to the cheeks, but leaves the mouth revealed. Originally, it would have been held up to the face by a baton in the hand. The Colombina is often decorated with more feminine flourishes, from gilding to gems and feathers, but both men and women may wear it.

Pantalone

"Big Pants" (sometimes called Il Magnifico) is a classic stage character who plays the role of father figure or another strong male lead. The Pantalone mask is characterized by a large nose, high brow, and slanted eyes.

Arlecchino (Harlequin)

Of the Commedia dell'Arte characters, Arlecchino, or Harlequin, is the most famous. On stage, Arlecchino appeared frequently with Pantalone as a dim-witted, mischievous, and comical counterpoint to the strong male lead. The Arlecchino mask is typically dark and characterized by a snub nose and protruding forehead. Arlecchino's costume is immediately recognizable for its familiar diamond-shaped patterning.

Dottore or Capitano

The character of Il Dottore is a rich, pompous know-it-all, quick to share his opinions with the other stage characters. His mask typically covers only the forehead and nose, and accompanies a bulky costume to suggest his gluttonous habits.

Zanni

Zanni is another servant character of the Commedia dell'Arte, an unlearned, meddling, and comic personage whose mask is characterized by a low forehead and elongated nose, not to be confused with the Plague Doctor below.

The Plague Doctor

The sinister-looking, beaked-nose Plague Doctor, or *medico della peste*, does not find its origins in the Venetian Carnival or in the theater, but rather in the harsh realities of disease in the pre-modern world. The mask owes its beginnings to the French doctor Charles de Lorme, who began wearing this peculiar-looking face covering as a sanitary measure while treating victims of the bubonic plague. In times of plague outbreak, the mask design was thought to help stem the spread of the bubonic plague by preventing the disease from coming near the doctor's nose as he treated patients. Typically the doctor wore a long cloak and gloves along with the mask and carried a stick that allowed him to examine patients without touching them.

Venice, a water-logged city and port to the rest of the world, was particularly vulnerable to outbreaks of plague and other diseases, so it comes as no surprise that the city's doctors readily adopted this mask. However, the use of the mask as part of a Carnival costume is a strictly modern practice.

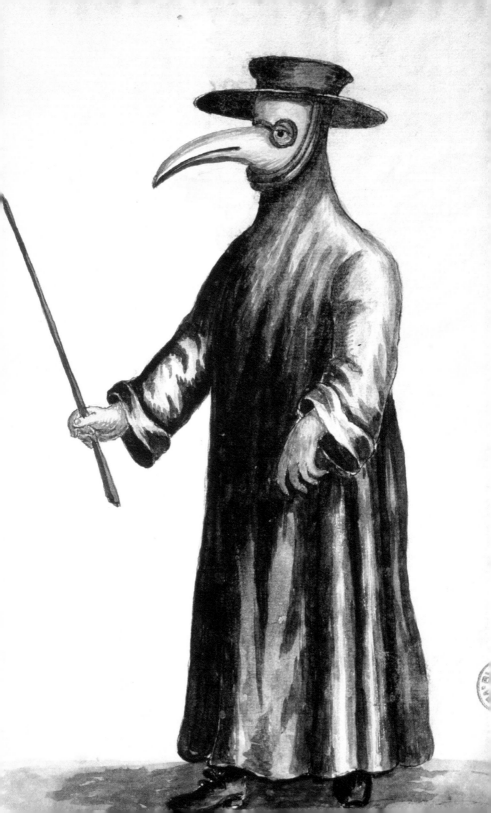

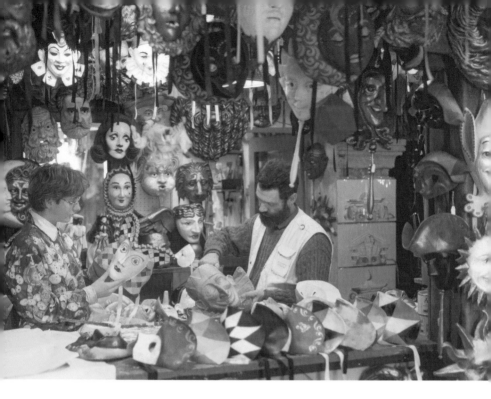

How to Choose a Mask

Carnival masks abound in Venice, from tourist traps to street vendors, and to the workshops of some of the city's most talented traditional artists. It is nearly impossible to walk down a major street in Venice without encountering masks. After hours of strolling the city's snaking alleys, you may feel overwhelmed at the variety, or have the feeling that all the masks begin to look the same.

The good news is that most Venetian mask makers welcome visitors into their studios to watch them work, ask questions, and buy off-the-shelf or custom designs. Take advantage of this excellent opportunity to learn more about this traditional art and meet the *mascarer* in person. It's also the best guarantee that you will pay the lowest possible price for a truly authentic Venetian work made by hand.

Some mask makers collaborate with costume specialists to create a truly stunning Carnival ensemble. If you plan to attend

Carnival, you may wish to avail yourself of a rented costume along with a mask to match. The practice of renting Carnival frocks dates back to the beginning of Carnival itself. During the Renaissance costume-renters stayed busy supplying wealthy Venetians not only with Carnival costumes and masks, but also with an ever-rotating assortment of finery for major public events and private parties. By renting your costume, you will take part in a centuries-old custom.

Today, some of the city's most traditional mask makers break from the past by fueling their creativity into more modern subjects and whimsical themes: masks of demons, dragons, and even Marilyn Monroe. A few workshops offer totally unique creations, so keep your eye out for one-of-a-kind masks. You may wish to splurge on a custom design, which should set you back no more than what you might pay for one of the elaborate off-the-shelf designs. Italian artisans are famous for their custom designs. Just ask!

Considering the amount of time, creativity, and labor that go into making an authentic Venetian mask, I consider masks a relative bargain and an ideal portable souvenir of a trip to Venice.

BUYER BEWARE

Carnival masks made of metal and ceramic have become popular in recent years in the trinket shops across town. These masks typically are not based on historical models. Also, be aware that many of these masks are not made by hand, but rather churned out in factories. Many are not even made in Venice. Steer clear of the masks you see hanging by the dozens in trinket shops and street vendor stalls. Instead, buy directly from a mask artist to ensure that you're buying an authentic and traditional mask.

Paper and Books

Venice claims an important position in the history of book-making and publishing. The city's geographic position as a gateway to the East, its preeminence in international trade, and its place as a center for knowledge exchange and artisanship made the Venetian Republic a natural setting for large-scale bookmaking to take root.

Prior to Johannes Gutenberg's invention of moveable type in the 1450s, each and every book was handmade. Books were precious, expensive, and highly coveted, prized possessions of monasteries and learned collectors wealthy enough to purchase them. Parchment vellum was made in a laborious process of preparing sheepskin in the tanneries, and a parchment sheath was never discarded, only occasionally scraped down and reused in a new book. Traditional monastic *scriptoria* could no longer meet the exploding demand for new books that occurred over the course of the fifteenth century.

With the innovations in moveable type, engraving, book printing, and distribution by the late 1400s, Venice was poised to be a leader in this expanding trade. Bookbinding studios, or *legatorie*, are documented in Venice by the 1450s, and bookmakers enjoyed esteemed social status. One of the most

influential publishers of the era was Aldus Manutius, whose *legatoria* in Venice typeset many scholarly books in Greek and Latin destined for scholars and universities all over Europe. A French-born engraver named Nicholas Jenson opened shop in Venice in 1470 after studying under Gutenberg and became an important figure in the history of type. Based on centuries-old, well-established trade routes, Venetian printers and publishers found easy distribution channels to the newly emerging booksellers across Europe.

Book production was a natural art for Venetians, who were already skilled at working with leather, pigments, and gold leaf. Knowledge of paper-making made its way from Asia to Europe during the Middle Ages. Venice, with its strategic location as the gateway to the East, was the natural place for this new art form to take root. From Venice, the tradition of decorative papers moved south to Florence, where it also flourished.

With the widespread use of moveable type instead of script, paper instead of vellum, and woodblock prints and engravings instead of hand-painted illuminations, the interior pages of books were dramatically transformed from their medieval predecessors. However, a book's exterior, its binding, remained essentially the same as its medieval models. Often, the *legatoria* only bound a book once a patron purchased it, and therefore the binding was customized and could be as simple or as fancy as the book buyer's budget and desire.

BOOKS AS PURVEYORS OF STYLE

If you read the chapter of this book on lace, you know that Venetian bookmakers created a large percentage of the lace pattern books that were disseminated across Europe, helping to propel Venetian lace to fame among the nobility.

TURKISH ORIGINS?

Venetians may have played a role in bringing the techniques of marbleized paper to Europe through their contacts with the Eastern Mediterranean, especially Constantinople (Istanbul). The method of paper marbling commonly practiced in Venice is sometimes referred to as "Turkish marbling" and its techniques are closely related to the Turkish art of paper marbling known as *ebru*. However, the earliest European books with marbled endpapers that survive today (from the 1500s) are German.

Early bookbinders discovered that when leather bindings came into direct contact with end papers, the result was discoloration and damage to the paper. They began facing the inside of the leather covers with hand-colored papers. This practice not only meant blank pages for creative and colorful paper displays, but also later the bookbinders realized they could reduce the amount of expensive leather they used in binding. Eventually, many bookbinders began using leather only for the spine, disguising the cover boards with colorful decorative papers.

The practice of "marbling" paper—decorating paper with colorful patterns that imitate marble veining—probably originated in China. By the fifteenth century these techniques had made their way across East and Central Asia. While the practice of using marbleized end papers was widespread in Germany and France by the seventeenth and eighteenth centuries, most Venetian and other Italian bookbinders used surprisingly little colored decoration, preferring plain, white end papers and focusing on the leather binding of the book itself. By the mid-eighteenth century, several prominent Venetian bookmakers incorporated marbleized paper into their repertory of woodblock

SPINAL ALIGNMENT

Medieval books were usually stored horizontally on the shelf, but later people began stacking them vertically, leading to extended hardcover bindings to protect the interior pages. Eventually, the title of the work would be stamped on the leather spine.

prints, copperplate engraving, leather binding, and other book production services.

The production of Venetian books involved specialists of several stripes—masters of leather, paper, engraving, printing, gilding, and other trades. Many famous Venetian painters, including Tiepolo and Canaletto, produced an enormous number of engravings and etchings during the middle of the eighteenth century, many of which were destined for bound books. Wealthy English travelers on the Grand Tour of Europe fueled demand for individual prints and books that contained prints by these well-regarded artists. These artists' *vedute*—or views—of Venice served as precursors to modern-day postcards for these international visitors who wanted to take a piece of Venice home with them.

How Books and Paper are Made

The first step in traditional bookbinding involves ensuring that all the folios or quires (gathered sections of a book) are properly ordered and assembled. Traditionally, the text block is then placed into a frame and sewn together with linen thread and long cords of vellum or leather. A modest softbound cover made of parchment, vellum, or soft leather might be attached by threading the linen threads through the cover and sewing them tight.

More expensive hardcover bindings are achieved by attaching stiff pasteboards to a hinged spine. The laces of the text block are fastened to the hinged edge of the pasteboards. Finally, the pasteboards and spine would be covered with leather, which may be punched, stamped tooled, gilded, or decorated using specialized bookmaking tools.

Marbleized paper (*carta marmorizzata*) is made by swirling pigments into a large, shallow pan of water, then laying the paper gently and briefly on the surface of the water to transfer the pattern. Because the designs sometimes mimic the natural veining in stone or marble, the word "marbleized" came to be used.

Marbleized paper is made across Asia and Europe, turned out with differing techniques depending on where it is made. In

TEXTILE CONNECTIONS

The techniques used to marbleize paper are closely related to the art of batik, laying pigments on fabrics. In fact, some paper artists are also active practitioners of fabric and fashion design.

Venice, paper makers traditionally began with viscous oil-based paints well-known to Venetian artists since the late Middle Ages. These pigments, known as *size* or *sizing*, derived from various plants, including widely available aquatic ones. Today, many paper artists prefer synthetic acrylics and oil paints. Artists apply the paints into a wide, shallow tray filled with water. Sometimes a surfactant is used to help the colors float on the surface. Traditionally, artists used ox gall to serve this purpose, though today there are synthetic surfactants on the market.

The creative aspect of paper marbling comes next, when the artist applies the colors to the water using any number of techniques—like dropping or splattering paint using paintbrushes, horsehair or straw whisks, or other tools—to apply color to the surface of the water in a particular design or order. After the color has been dropped, the artist may use a variety of tools—including rakes, styluses, combs, brushes, or even a single hair—to create swirls, lines, and other design elements in the paint.

Traditional Marbled Paper Designs

Much in the same way that Italians name pasta shapes after animals and household objects, some of the most popular marbleized paper designs are inspired by familiar images. Look for these common designs among the *legatorie* across town:

Chiocciola (snail) or conchiglia (shell)

With a beautiful sense of movement, the shell pattern is made by forming each coil with a stylus. This pattern was used widely in book end papers of the Renaissance period.

Marmo pettinato (combed marble)

This design is created by dragging a rake-like tool through the pigments, disturbing the horizontal lines and giving the impression of having been combed.

Pavone (peacock)

The appearance of peacock feathers is achieved with a special comb and rake. This is one of the most common patterns of paper marbling.

How to Buy Paper and Books

Shops all over Venice sell blocks of elegant stationery, sheaths of handmade paper, leather-bound books with marbleized end papers, and a host of related items from fountain pens to wax seals, agendas, diaries, and calendars. Most of the books you see in the shops are commercially bound, and the marbled papers are machine-printed rather than handmade. However, there are a few old-fashioned *legatorie* fashioning book bindings and making papers by hand.

The most cost-efficient and authentic approach to buying paper is to buy handmade pieces by the sheet. These papers may be used as giftwrap or framed and hung on the wall for a beautiful display. Packaged into a stiff, cardboard tube, handmade paper sheets make an ideal portable Venetian souvenir.

Finally, if you are interested in pursuing bookbinding and paper making further, you can arrange for a one-on-one or small group class among the city's artisanal bookmakers.

A PIECE OF THE PAST

A fabulous way to pick up a unique piece of Venetian history is to purchase an old book from an antiquarian bookseller or antiques market in Venice. Many of these books are hand-bound. Keep your eye out for printers' marks or logos in the first few pages, which will give you information about the origin of the publisher or printer. And don't forget about prints, many of which were detached from antique books at some point in history. You can pick up beautiful etchings and engravings by known Venetian artists at many antiquarian shops across the city.

Resources

Visiting Venetian Artisans

Many stores and artisan workshops in Venice are multigenerational enterprises, some in operation for a century or longer. However, change is inevitable and sooner or later, businesses relocate or close. The older members of the family pass on, and the new generation takes the family tradition in a new direction. It is frustrating for travelers to go to the trouble to buy a guidebook and locate an artisan studio, only to find it shuttered or relocated.

For this reason, rather than listing specific artisans here, I have created a separate ebook complement to this guide called *Artisans of Venice*. I conceived *Artisans of Venice* as a digital companion to this book. My goal for *Artisans of Venice* is to keep the listings as updated as possible in order to ensure the best experience for you as a traveler and shopper.

You can download *Artisans of Venice* as a
PDF file, and print it if you wish, from my web site
at **www.lauramorelli.com**, or download the book to
your ereader from your favorite online book retailer.

While having list of high-quality artisans is convenient, it does not replace the acute eye of a discerning shopper. The skills you need to select a quality work of Murano glass or a traditional piece of Venetian lace will never change. It's all about training your eye to recognize styles, patterns, artistic conventions, quality, tradition, and value. With this book, *Authentic Arts: Venice*, it is my goal to arm you with the information you need to make smart choices, no matter which shop or market you visit. The resources below should put you well on your way to being among the most informed, educated shoppers in Venice. Enjoy your trip!

Museum Collections of Authentic Venetian Arts

It goes without saying that Venetian museums are a treasure trove of authentic arts, but they are also a great place to train your eye before you visit the artisan studios and shops. Before you buy anything, I recommend spending a little time looking at historical examples of the works you have in mind. You'll come away with the ability to recognize traditional colors, patterns, styles, and conventions, and you'll be better equipped to discern quality and authenticity when you hit the streets. Check the museum web sites for current information about opening hours and admission fees, and to buy tickets online where available.

Ca' Rezzonico
Dorsoduro 3136
www.carezzonico.visitmuve.it

The Ca' Rezzonico is part of the city museum network, and is housed in the opulent former palace of the Rezzonico family along the Grand Canal. On the ground floor stands a nineteenth-century gondola with its passenger compartment (*felze*) intact.

Museo vetrario (Glass Museum)

Palazzo Giustinian
Fondamenta Marco Giustinian, 8
Murano
www.museovetro.visitmuve.it

Before heading off to the glass factories, visit the glass museum to train your eye to recognize distinctive shapes, colors, and styles from the history of Murano glass. You may be surprised! I had always thought that the miniature mice and horses crafted of Murano glass were a product of modern kitsch taste, but I was wrong. Glassmakers made them even in the seventeenth century, and you can see these creatures and other glass wonders in this fantastic museum collection assembled beginning in the 1860s.

Museo Correr

Piazza San Marco, 52
www.correr.visitmuve.it

Years ago several gondola prow forks dating probably from the 1600s were pulled from the canal waters. You can admire their beautiful curvilinear profiles at one of the civic museums of Venice, the Museo Correr. This intriguing museum began with the private collection of Teodoro Correr, a member of an old Venetian family and a passionate collector of Venetian historical objects—everything from paintings to coins, nautical instruments, arms and armor, and other fascinating miscellanea. The museum also holds numerous examples of Venetian lace from the sixteenth century onward.

Museo storico navale (Naval History Museum)

Castello 2148

In addition to impressive collections relating to the history of the Venetian state shipyard, the Arsenale, this maritime museum also includes a gallery dedicated to the history of the gondola. It even displays the gondola that Peggy Guggenheim used as her preferred mode of transportation around the city.

Museo del merletto (Lace Museum)

Palazzo del Podestà
Piazza Baldassare Galuppi, 187
Burano
www.museomerletto.visitmuve.it

To feast your eyes on some of the world's most exquisite lace, head to Burano's impressive lace museum. This is one of the few places to view genuine Venetian lace made using traditional methods. More than 350 pieces of stunning lacework are showcased in rotating exhibitions. On most days, you can watch lacemakers working with their needle and thread, and gain an appreciation for the painstaking nature of this tradition.

Palazzo Ducale (Doge's Palace)

Piazza San Marco
www.palazzoducale.visitmuve.it

Along one of the corridors of the Doge's Palace is a nineteenth-century gondola complete with its passenger compartment, or *felze*, intact.

Arts Associations

Organizations that preserve traditional arts tend to operate quietly behind the scenes, often with limited public presence and access. However, these organizations are often treasure troves of information and resources, staffed by knowledgeable professionals who are passionate about their work. They can help facilitate access and point you in the right direction if you are looking for something specific. If you want to dig deeper below the surface of the artisan shops and museums with a more public presence, contact one of the organizations below.

Arzanà

Calle delle Pignatte, 1936/d
Cannaregio
www.arzana.org
associazionearzana@gmail.com

Arzanà is a nonprofit organization dedicated to the preservation and restoration of historic Venetian boats, including gondolas. They have a fascinating collection of boats and gondola fittings, including oarlocks, ropes, oars, upholstery, *ferri*, and other curious vestiges. The offices and collections are not open to the public on a regular basis, but private visits may be arranged at least a month in advance by email.

Consorzio Promovetro Murano

Promovetro
Calle M. da Murano, 4
Murano
www.promovetro.com
www.muranoglass.com
info@promovetro.com

Promovetro is a trade organization that helps promote and protect Murano glass. The consortium has developed a trademark, designated with the words Vetro Artistico Murano, which is now protected under regional law. This group has also developed an app for you to download on your smartphone, complete with current, updated listings of the Murano glassmakers who use the trademark in their work. Promovetro can help facilitate visits and provide further information about the glassmakers on Murano.

El Fèlze

www.elfelze.org

Founded in 2002 by the oarmaker Saverio Pastor, El Fèlze is an association of artisans involved in the various gondola-making trades. Although they do not have an office open to the public, El Fèlze can provide information and help facilitate visits to specific studios of masters involved in the making of gondolas and their fittings.

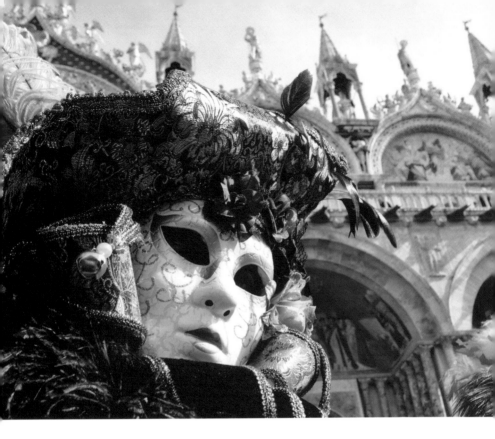

Festivals

Italians take their festivals seriously. In Venice, the sheer variety and frequency of its traditional festivals means that there is something authentic to experience all year round. Nearly anything can be cause for celebration—a saint's day, a religious or civic holiday, the ripening of a certain vegetable, the unveiling of the season's wine, remembrances of important historical events, and of course, Carnival. Traditional arts often take center stage at these cultural extravaganzas, as they serve as a source of local pride and collective memory. Here are Venetian festivals in which artisanal traditions play a key role.

January
La Regata delle Befane
January 6

If you see a group of gondoliers dressed like old women with bonnets and crocheted shawls, check your watch. You've probably arrived in Venice on Epiphany, a national holiday in Italy celebrated on January 6. The religious significance is typically overshadowed by the arrival of Befana, a witch-like, broom-riding old woman who, according to Italian tradition, leaves candy in children's stockings the night before Epiphany. In Venice, Befana not only powers brooms but also powers gondolas and other boats through the canals in this most curious of Venetian *regatte*.

February–March
Carnevale (Carnival)
10 Days Before Lent
www.carnevaledivenezia.com

Arguably the world's most famous Carnival, Venetian Carnival is the best place to see traditional handmade masks and costumes in action. If you want to splurge, procure a high-priced ticket to one of the official masked balls like the Doge's ball or the Gran Ballo della Cavalchina. You can rent an extravagant costume and locate a mask from one of the city's traditional mask makers.

April
Feast of San Marco
April 25

This celebration of the city's patron saint includes a regatta of historic gondolas between the Punta della Dogana at the entrance to the Grand Canal and the island of Sant'Elena following mass in the basilica.

May

Festa e Regata della Sensa
(Feast and Regatta of the Sensa)
40 days after Easter

This particularly Venetian event, celebrated on Ascension Day, commemorates the city's close link with the sea. Historically, the Doge of Venice would board the Bucintoro, the outlandishly ornamented state barge, and travel to the island of Sant'Andrea, where he would cast a gold ring overboard to symbolize the city's marriage to the sea. Today the mayor of Venice does the honors from a gaudy historical replica of the Bucintoro at San Nicolò on the Lido. A regatta of historic Venetian boats follows.

June or July

Palio delle Antiche Repubbliche Marinare
(Race of the Maritime Republics)

In this heated race between Italy's four former maritime republics (Amalfi, Genoa, Pisa, and Venice), the Grand Canal becomes a moving stage for historic gondolas and other boats carrying passengers with the traditional costumes and masks of Venice. Each of the representatives of the four republics dresses in costume, and before the race you can watch the parade along the riva dei Sette Martiri and the riva degli Schiavoni.

July

Il Redentore (Feast of the Redeemer)
Third Sunday in July

This procession of the city's historic gondolas commemorates the end of a plague epidemic that struck Venice in 1576 and is the oldest continuously celebrated festival in the city. On the Saturday before the religious festival, boats and their rowers gather in the lagoon between Saint Mark's Square and the Giudecca, their rowers bedecked in finery, and it's a great chance to see a large number of historic lagoon craft. A flotilla of connected boats forms the foundation for a temporary bridge across the canal to the island of Giudecca.

September

Regata Storica (Historic Regatta)
First Sunday in September
www.regatastoricavenezia.it

This popular race includes four categories of rowers—youths, women, rowers of a canoe-like craft called a *caorlina*, and gondoliers. The gondolas are manned by two rowers, and the race is eagerly followed. Prior to the race you can watch a procession of historic gondolas with people dressed in Renaissance costume. A similar historic regatta takes place on Burano during the third week of September.

Other Surprising Discoveries

Museums and artisan studios are not the only places in Venice to explore traditional arts. Some of the most fascinating and authentic finds appear in unexpected places—on the side of a church altar, in a street-corner shrine, on a sign in the alleyway. Don't miss these fun opportunities to immerse yourself in Venetian artisanal history.

Our Lady of the Ferry Station

Ponte della Paglia
San Marco

This sixteenth-century shrine to the Madonna and Child is carved into the side of the Ponte della Paglia. That's the bridge where tourists stand to take a picture of the more famous Bridge of Sighs near the Piazza San Marco. Most people miss what lies below them. The shrine to the Madonna and Child is carved in high relief into one of the spandrels of the bridge so that it is visible to gondoliers as they glide underneath the bridge's arch. Below the image of the Madonna and Child are two carved gondolas with passenger compartments (*felzi*). This area was once the spot of one of the city's many *traghetti* (ferry stations), the Renaissance equivalent of a taxi stand.

Gondola Altar

Church of San Trovaso
Dorsoduro

Inside the Church of San Trovaso stands an altar completed in 1628 and dedicated to the gondola makers' guild. If you look carefully you will see an image of a gondola, complete with its prow forks (*ferri*) and passenger compartment (*felze*), carved into the side of the altar itself.

Glass Mosaics and Dragon Bones

Basilica Santi Maria e Donato
Campo San Donato
Murano

Don't leave the island of Murano without visiting this beautiful medieval church with its twelfth-century floor mosaic crafted from glass *tesserae* (pieces) fired in the furnaces of Murano. The church contains not only the relics of San Donato, but also, according to legend, several bones of the dragon San Donato slayed simply by spitting on it.

Street Signs that Recall
Traditional Trades of Venice

One of my favorite things to do in Venice is to "read" its history as I walk. Whether you read Italian / Venetian or just have a good dictionary, pay attention to the street signs. The great blocks of etched stones, each with a name—sometimes more than one— tell the story of the city. What's more, the makers of glass, masks, gondolas, lace, and other centuries-old trades live on through these markers of their memory.

Glassmakers:

Calle dell'Artigiano (Murano)
Calle delle Ceramiche (Murano)
Calle del Forno (Murano)

Gondola makers:

Campiello dei Squeri (Burano)
Campo dello Squero (Castello)
Ponte dello Squero [or della Racheta] (San Marco)
Calle dei Squeri (Burano)
Calle del Squero (Castello)
Calle del Squero (Cannaregio)
Calle del Squero (five different streets in Dorsoduro have this name!)
Calle del Squero (two different streets in Giudecca)
Calle del Squero (San Polo)
Campiello del Squero (two squares in San Polo)
Fondamenta dei Squeri (Burano)
Fondamenta del Squero (San Polo)
Ramo Squero (Giudecca)
Calle and Sottoportego del Squero Vecchio (Cannaregio)
Calle, Corte, and Sottoportego del Squero (Cannaregio)
Calle Storta dei Squeri (Giudecca)
Campiello Squero (Dorsoduro)
Fondamente del Squero (Dorsoduro)
Ramo del Squero (Castello)
Ramo del Squero (Dorsoduro)

Lace makers:

Calle del Pizzo (Burano)
Fondamenta del Pizzo (Burano)
Rio Terrà del Pizzo (Burano)

Oarmakers:

Campiello del Remer (Cannaregio)
Corte del Remer (Cannaregio)
Sottoportego del Remer (Cannaregio)

Keep your eyes out for these and many other street names that recall the old vocations of Venice, keeping the memory of these trades alive.

For up-to-date listings of Venetian artisans practicing traditional trades, download your copy of **Artisans of Venice** by Laura Morelli from **www.lauramorelli.com** or your favorite ebook retailer.

Index

About the Author

Laura Morelli earned a Ph.D. in art history from Yale University, where she was a Bass Writing Fellow and an Andrew W. Mellon Doctoral Fellow. She has taught college art history in the United States and Italy and has lived in five countries. She is the creator of the guidebook series that includes *Made in Italy*, *Made in France*, and *Made in the Southwest*, as well as an award-winning historical novel set in 16th-century Venice entitled *The Gondola Maker*. She is a frequent contributor to *National Geographic Traveler*, *USA Today*, and other national publications.

I hope you enjoyed this book! If you would like to join my email list to learn about events and new releases, sign up at **www.lauramorelli.com**.

—Laura Morelli

Also by Laura Morelli

The Gondola Maker
Award-Winning Novel

Made in Italy • *Made in France*
Made in the Southwest

Laura Morelli's Authentic Arts Series:

Florence • *Naples & the Amalfi Coast* • *Paris*
Provence & the French Riviera • *Sardinia*
Sicily • *Tuscany & Umbria* • *Venice*

CPSIA information can be obtained at www.ICGtesting.com
Printed in the USA
LVIW01n2231180615
442914LV00001B/1